D0988900

AMERICAN INDIAN ART

The Collecting Experience

Elvehjem Museum of Art
University of Wisconsin-Madison
May 7-July 3, 1988

Catalogue by Beverly Gordon with Melanie Herzog

Exhibition Organized by the Elvehjem Museum of Art

Guest Curator: Beverly Gordon with Frances Potter and Melanie Herzog

American Indian Art: The Collecting Experience is supported in part by grants from the Dane County Cultural Affairs Commission, the University of Wisconsin-Madison Consortium for the Arts, Humanistic Fund Committee, and Anonymous Fund Committee.

Front Cover:
David Phillips (Hopi) clown (koshare) figure 1985

Copyright 1988
The Regents of the University of Wisconsin System
All rights reserved
ISBN 0-932900-18-6

Foreword

In 1984, an outstanding collection of eighty-three American Indian baskets was donated to the Elvehjem Museum of Art by Mr. and Mrs. Theodore Van Zelst. That gift, part of which was made in their own name and part in the name of their daughter and son-in-law Anne and Brad Orvieto, was enthusiastically received partly because the Elvehjem owned no American Indian art, but principally because the collection was exceptionally coherent and of a uniformly high quality. The Van Zelsts are, after all, acknowledged experts in the field of American Indian art and their years of study and dedication have resulted in a collection of baskets that the Elvehjem could not hope to acquire through purchase and which is, in addition, ideally suited to the Museum's teaching mission.

The acceptance of works of art into the permanent collection carries with it obligations of study and display. An ad hoc committee was first assembled in the autumn of 1985 to develop an appropriate curatorial context for the exhibiting of the Van Zelst Collection. It was during one of the committee's initial meetings that Beverly Gordon, Assistant Professor in the Department of Environment, Textiles and Design (School of Family Resources and Consumer Sciences) proposed "Collectors and Collections of American Indian Art" as a theme for an exhibition.

Since the Van Zelst Collection was not put together by museum professionals or scholars with an archival purpose but by people with a passion for American Indian art, people who in the pursuit of this passion have developed a profound knowledge and understanding of the art, it was felt that an exhibition highlighting the collecting experience would be most appropriate. Who are these collectors of American Indian art? What motivates their passion for collecting? Are there others with similar interests? What is actually worthy of collecting? These are questions that intrigue the curator and the scholar as well as the general museum visitor. The Elvehjem therefore decided to pursue the proposed project. Subsequently, Beverly Gordon agreed to serve as chief curator to the exhibition.

The Elvehjem is especially grateful to Professor Gordon and Frances Potter; for without their scholarly and organizational skills the successful completion of this project would not have been possible. The Elvehjem also wishes to acknowledge the invaluable work of Melanie Herzog who assisted in all phases of this project. Dawn Danz–Hale assisted in the preparation of the catalogue.

As usual, the Museum staff diligently carried out the various tasks that are so essential to the success of any exhibition. Special recognition must be made of the efforts of Kathy Parks, Assistant to the Director, who coordinated countless administrative details; of Earl Madden from the University of Wisconsin Publications Office who designed the exhibition catalogue; of Loni Hayman for her editorial skills and meticulous attention to detail; of Lisa Calden, the Museum Registrar, for handling the essential paperwork and bringing the works of art safely to Madison; of Sandra Pierick whose accounting skills assured the project of sound fiscal management; of Sherill Tremelling who so patiently typed the various lists; of Liz Loring who photographed the seven collections; and finally of Thom Brown, thanks to whose creativity and skill we owe the exhibition's design and installation.

Other individuals whose insights and advice helped shape the exhibition and thus deserve mention include Virginia Boyd, Ada Deer, Joy Dohr, Fred Fenster, Joan Freeman, Truman Lowe, Nancy Lurie, and Catharine McClellan. We also wish to thank the following students who have been more than willing to assist with the innumerable details that an exhibition like this entails: Diana Dicus, Rebecca Haber, Merrill Horswill, Maxine Johns, Julie Loehrl, Anne Martella, Julie Statz, and Julie Trestman.

Our greatest debt of gratitude is owed the collectors who so graciously welcomed Beverly Gordon and others working on this project into their homes and then agreed to lend their prized works of American Indian art to the Elvehjem. Loan exhibitions such as *American Indian Art: The Collecting Experience* leave blank walls and empty shelves, a painful sight for collectors with a strong personal involvement in the works collected over so many years. All those associated with the exhibition are therefore especially grateful to Mr. and Mrs. Curtis Busse, Mrs. Martha Lanman Cusick, Dr. and Mrs. Larry Hootkin, The Little Eagle (Tallmadge) Family, Mr. and Mrs. George Marsik, Mr. Bob Smith and Mr. and Mrs. Theodore Van Zelst. And, of course, we thank once again the Van Zelsts, whose gift of American Indian baskets to the Elvehjem not only enriched the Museum's permanent collection but also gave the impetus to an exciting and valuable project.

Russell Panczenko
Director

Introduction

American Indian Art: The Collecting Experience presents selections from seven collections of American Indian art from Wisconsin and surrounding areas. Each collection has come into being under a different circumstance, and is guided by a unique attitude or philosophy. The owners are all strongly involved with their objects, which become saturated with meaning and evoke a wide range of emotional, intellectual, and spiritual responses.

All collections take on or are imbued with some of the psychic energy of their owners,[1] but collections of Indian art seem to evoke particularly strong feelings. The artworks are seen as concrete, tangible expressions or manifestations of Indian people and the Indian way of life. This is not a "neutral" topic; all Americans (and to a certain extent, all Westerners) grow up with myths and assumptions about Indians, and with both positive and negative associations. These associations are brought, however subtly and unconsciously, to the artworks.

This exhibition attempts to bring some of these associations to the foreground. It treats each collection as a discrete entity, and attempts to clarify the underlying meaning in each case. The exhibition is concerned with the artistic interests of the collectors, and with the relationships with or attitudes about Indians that the collections embody. Sometimes, as in the two collections that have been put together by individuals who are themselves Indian, the relationship is direct. At other times it is less so, but it is still implicit.

These seven examples are not representative of the whole range of collecting, of course, nor do they encompass all areas of Indian art. The work of the Northwest Coast peoples, for example, is represented by only a few baskets, despite the fact that it is of significant historic and aesthetic importance and is avidly collected by many individuals. No paintings by contemporary Indian artists are included either, even though there are exciting developments in this area. The exhibition represents, rather, representative examples of the collecting patterns and interests of these particular collectors.

The exhibition and the collections themselves also exist at a particular point in time. Many of the ways these objects are perceived and experienced are determined or influenced by the broader context of contemporary culture—by the range of attitudes, events, and ideas that the collectors are exposed to, especially in relation to the ways Indians and art are viewed and understood in the present time. In order to understand this contextual level of meaning and to place these seven collections in a historical context, the discussion of the collections is preceded by an overview of the evolution of Indian/white relationships and the general American perception of Indians and Indian art. We may hope that the richness and depth of both Indian art and the collecting experience is woven into this presentation. It is our wish that the visitor/reader will be able to enter into that experience to some extent, and to share in its excitement and satisfactions.

Collecting Indian Art: The Historical Context

Defining Indian Art

What, first of all, *is* Indian art? Can any object made by a North American Indian[2] be considered art? Can the definitions and assumptions that have evolved in Western culture—that there is a distinction between "major" and "minor" arts, and that true artworks must be non-functional, individual statements—be applied? These issues have been inconclusively debated for decades. Most of the visual expression of American Indians has traditionally been invested in functional objects such as tools, containers, and clothing, and the pieces generally reflected a collective or group aesthetic rather than a unique personal vision. There have always been individual Indian artists, however: basketmakers, potters, and garment-makers have gone through training processes, just as painters or sculptors do, and they have always approached each of their pieces as a unique aesthetic challenge. Like western painters, they speak of creative inspiration and guidance, and many dream about their work.[3] Good artists have always been recognized by their communities; their work was in constant demand. In addition, Indian art was never limited to traditional or functional objects; there have long been individual experiments and items made for the sheer joy of the visual image,[4] and in recent decades there has been an outpouring of Indian artworks in "non-Indian" media such as oil painting and printmaking.

If western definitions are inadequate, Indian definitions are no more accurate. Many tribal languages have no word that can be translated as "art." American Indian culture is not monolithic—there are hundreds of Indian cultures and languages—and just as there is no such thing as *"the* Indian," it is not really possible to discuss *an* Indian aesthetic. Most native groups share a general spiritual perspective, however, one that shapes a particular type of aesthetic sensitivity. Indian art has been defined as a "visual metaphor for a spiritual attitude," a way to relate to the supernatural world.[5] Many Indians tend to speak of art as a way of approaching the world rather than as a particular kind of artifact. (Even in this small sample of seven, the most broadly defined collections are those of the Indian collectors.) The approach is perhaps best approximated by the Navajo term *hozho,* which has often been translated as "beauty," but involves a more comprehensive idea. *Hozho* can be understood as a state of harmony, a perfect balance. Art is not a rug or a painting or a thing at all. Rather, it is evident in those things if they are well done. Objects, like people, project beauty or harmony outward, but they are dynamic rather than static, and they are primarily important not in themselves but as manifestations of harmonious, good living.[6]

Collecting Curiosities

The first Europeans who came to the New World were, ironically, interested in collecting pieces of the Indian lifestyle. They thought of themselves not as collecting Indian art, but of amassing souvenirs or "curiosities." There was a genuine interest in these unknown peoples; a fascination with their "otherness." Even the earliest explorers were collectors. As we might expect, Columbus brought Indian objects back to Europe.[7] Seventeenth-century explorers avidly collected objects decorated with porcupine quills. One observer claimed that every sailor who docked in what is now the Canadian Maritime region was anxious to procure a quill-worked purse, and the Indian women "knew well how to inculcate a desire for them." On the Northwest Coast, early visitors like Captain Cook were greeted by natives who immediately offered them things for sale.[8]

By the late eighteenth century, numerous individuals had amassed sizeable collections of curiosities. Typically, natural botanical or animal specimens were intermingled with "artificial" objects—all were seen as integral pieces of the exotic, non-European world. They were even displayed together in treasured cases or "cabinets." Isabella Grant, who had lived with her husband in the Great Lakes region of Canada at the turn of the nineteenth century, listed her Cabinet of Curiosities as one of her most important possessions in her will, and bequeathed it to her daughters.[9] Cabinets were also sometimes opened to the public,[10] and by the 1830s were so common that one observer complained that good examples of Indian items were already difficult to find in Minnesota.[11]

Such collections were valued as evidence of Indian life, but they were unstructured, arbitrary groupings of objects, that no more attempted to present a comprehensive picture of the Indian reality than they did to present the objects as artworks. Clearly, this was a reflection of the distance Europeans perceived between themselves and the native peoples. Sometimes that distance was perceived as positive. There were still those who saw the Indian

as a "noble savage," a part of the natural world, as pure and as uncorrupted as nature itself. This is the vision that had led Revolutionary cartoonists to adopt the Indian as a symbol of the new nation, and it is the image that appeared in romantic fiction, poetry, and art.[12] By the nineteenth century, however, the image had become largely negative. Efforts at conversion had been only marginally successful, and the Indians' rejection of Christianity and European civilization was seen as a sign of their innate depravity or inferiority. As hostilities increased over territorial disputes, the prevailing perception shifted from noble to "bloodthirsty," filthy and lecherous, untrustworthy, and indolent.[13] In either case, Indians were "other"—not real, multifaceted and individual people, but something alien to and in fact the very antithesis of traditional white civilization. Indian artifacts could be collected and displayed with no sense of context because the people that made them were perceived with little or no context of their own.

Nineteenth-Century Contexts: Documentation by Artists and Ethnologists

One of the first to insist on some contextual information was George Catlin, an artist who, according to his contemporaries, had an "over-enthusiasm for savage life."[14] Catlin appreciated the spirit and artisanry of the Indian people, and worried that the encroaching western expansion was threatening Indian culture. Starting in 1832, he travelled among the tribes of the upper Missouri and the southern Plains, and attempted to document their way of life. He collected a range of objects—garments, weapons, pipes, and the like—and wherever he went, he sketched and painted the people he saw in their native habitat. He offered his pictures and objects to the American government in 1837, but the collection was turned down. Undaunted, he took the "Indian Gallery" on tour, and published the portraits with "notes on Indian manners, customs, and conditions." Catlin's concern was for Indian life as a whole, and although one reviewer claimed he tended to illustrate ornamental rather than useful Indian products,[15] he considered himself an historian, and took pains to present the objects in their proper settings. He displayed a tipi as a living space, for example, with its accoutrements, and when he displayed garments, he set up mannequins and prepared life masks that represented the individuals who made and wore them.[16]

Catlin's presentation of Indians was not wholeheartedly accepted by the American public; one of the reviews of his works compared his attitude to a lion tamer's empathy for his beasts, and another stated, "in spite of ourselves, he almost gives us his own liking for the Indians . . . we are almost for a moment involuntarily convinced that the savages are humane."[17] His interest in the Indian lifestyle did, however, begin to find emulators by mid-century. Some of this interest came from fellow artists. John James Audubon, for example, not only collected Indian articles when he travelled to the Yellowstone River to sketch and study birds and animals; he took care to document the pieces. Arthur Lee, John Mix Stanley, Vincent Colyer and others also illustrated Indian life and collected fine examples of Indian work. Albert Bierstadt, one of the most popular painters of the period, did not go on collecting expeditions, but he was so taken with Indian items that he hung them all over his studio.[18]

Other interest came from an early generation of ethnologists. Lewis Henry Morgan, often considered the "father" of American anthropology, amassed an Indian cabinet that was anything but a haphazard assemblage. Convinced that western civilization was displacing and destroying native traditions, Morgan carefully labelled and described each object and combined collecting with extensive observations of ceremonies and other cultural activities.[19] Morgan's view, like that of subsequent ethnographers, was sympathetic, but it was based on a premise of inevitable "progress," or social evolution. Just as there were primitive and advanced forms of animal life, the theory went, so too there were stages of social progress. Human groups passed from states of savagery to the most evolved form, "civilization." Indians and other "primitive" groups were remnants of early, less evolved humankind, whose cultures would inevitably cede to that of the whites. Indian lifeways were interesting to study, therefore, as examples of these early stages; their habits and beliefs provided insight into what anthropologist Otis Mason called "[the 'civilized' people's] own ancestors." Consequently, Indian artifacts were now ordered in progressive groupings or series, starting with the "most primitive" object and moving to the "most advanced." Items made by different tribes might be mixed indiscriminately (indeed, they were often mixed with objects from different continents—the important point was the evolutionary stage they represented),[20] and the overall effect was a continued stereotyping and distancing, based on a failure to perceive Indians as distinct and real individuals.

The "Vanishing Indian" and the Turn-of-the-Century Collecting Craze

The white assumption that native peoples were in an inherently inferior state justified governmental policy that was essentially based on a desire to eliminate resistance to land acquisition. Although Indian people were conquered, massacred, and forced to leave their lands in the pre-Civil War period, their tribal structures were at that time still acknowl-

edged, and tribes were seen as independent entities. Official policy and public perception shifted in the 1870s and 80s by which time even the "fierce" warriors of the western Plains had been "removed" to contained reservations, and people believed the Indian could be civilized through assimilation into mainstream culture. In 1887 the Dawes General Allotment Act was passed by an overwhelming margin. This legislation bypassed the tribe and divided Indian lands into separate, family-sized plots. The idea was that once Indians had private property, they would begin to think like homesteaders and would become more like whites. Other policies were instituted to reinforce the assimilation process: native rituals and even native languages were suppressed or forbidden, and Indian children were sent away to "American" government schools. "The Indian" would soon "vanish"; Indian individuals might survive, but their indianness, their tribal identity and their way of life would become something of the past.[21]

Ironically, the assumption of assimilation led to a sentimental, nostalgic new interest in Indian things. Once the public felt that "night was about to swallow" the Indian way of life, it wanted to hold on to it in some way, and a craze for collecting Indian objects began.

There were two aspects to the turn-of-the-century collecting boom, although they interpenetrated one another at many points and both stemmed from the same belief in the vanishing Indian. On one hand there was interest and activity on a professional or institutional level. New museums, including the Museum of Natural History in New York and the Field Museum of Natural History in Chicago,[22] began to send people out on collecting missions to get as much material as they could from the "dying" cultures. Attempts were made to fill in "gaps" in the collections. Comprehensive ethnographic documentation being the goal, aesthetic concerns were not one of the collecting criteria.[23]

The second major thrust of turn of the century collecting took place on a more popular level. The general perception that Indian ways were a phenomenon of the past was so pervasive that a 1899 illustration in *Harper's Weekly* satirically portrayed two Indians on wooden merry-go-round horses[24] and the 1902 Sears and Roebuck catalogue offered a stereopticon set entitled "The Passing of the Indian."[25] "Everyone" wanted to capture some small piece of this vanishing part of America and eagerly sought examples of Indian beadwork, baskets, and other objects. Interest in "the Indian question" had grown in the 1880s, when reform groups were stirred by Helen Hunt Jackson's indictment of the government's Indian policy in a muckraking work, *A Century of Dishonor* (1881) and a novel about the plight of the Mission Indians of California, *Ramona* (1884).[26] The same outcries against Indian removals

that inspired the Allotment Act in 1887 also stimulated an interest in and appreciation of Indian products. Several scholars cite *Ramona* as one of the pivotal forces in creating a new interest in Indian baskets, in particular.[27] (*Ramona* did not actually discuss basketry, but its Indian heroine was presented in such a positive and sympathetic light that its readers began to identify with her.) The book was continually reprinted for forty years, and was read by millions.[28]

There were also other factors in the new wave of popular collecting. In addition to the growing body of written material about Indian products, there was a new wealth of visual images. Photographs were published in books (the first volume of Edward Curtis' *The North American Indian* came out in 1903), and in popular magazines. *Scribner's, Harper's Weekly, Cosmopolitan* and *Country Life in America,* among others, included illustrations of Indians on a regular basis. Even more important in bringing Indian imagery to popular attention was the picture postcard. Postal regulations were altered in 1898 to allow privately printed cards to be sent through the mail, and postcard exchange quickly became an American passion.[29] Images of Indians were often staged and romanticized[30] (see 64),* but they caught the popular imagination and whetted the appetite for the picturesque objects they portrayed.

The postcards often coupled images of Indians with those of natural attractions or tourist sites. Cards sold at the Grand Canyon featured Havasupai Indians weaving baskets, for example, and cards sold at Niagara Falls or Wisconsin Dells featured Iroquois or Winnebago Indians, respectively, in beaded costumes. Railroad companies included images of Indians in promotional materials and even in timetables.[31] Long-held stereotypes of the "wild," "natural" Indian fed romantic fantasies about travel and exploration. It was in this turn-of-the-century period that tourism came into full bloom with extensive railroad development,[32] and the new desire for travel, coupled with the popular belief that the native way of life was disappearing, created a new hunger and an unparalleled demand for Indian souvenirs.

Native people across the continent responded with alacrity. Items that had formerly been made primarily for internal, tribal use became commodities that could generate income, and were produced in unprecedented numbers. Products were also adapted and modified, or even invented for the new market, and people who had not previously spent much of their time producing artwork began to do so. According to the 1890 census report on Indians in New York State, for example, at least one member of every family—approximately one-sixth of the population—of the St. Regis Iroquois Reservation was involved in making baskets (see 11 for a similar

*Numbers in parentheses refer to the catalogue entries.

example), and each family earned an average of $250 from basket sales that year. Beadwork (see 110–116) and other art forms were also being produced on the same reservation in that period.[33]

Similar situations prevailed elsewhere. Once railroad lines were extended to the Navajo reservation about 1880 (see 46), increasing numbers of Navajo women began to weave textiles to sell to white people rather than for their own use or for trade with other Indians. Production was also stimulated by the white entrepreneurs who were granted government licenses to set up trading posts on the reservation to exchange foodstuffs and manufactured goods for native weavings.[34] Such trading posts were most influential in the Southwest, but the presence of entrepreneurs and middlemen had a significant impact on Indian art all over the continent.

Not only did traditional Indian art forms continue to thrive, but in some cases dormant traditions were actually revived (see discussion on Nampeyo, p. 45; 58–59). However, much of what the public purchased as manifestations of a dying way of life were actually new, innovative products that blended Indian traditions and practices with mainstream American concepts and taste. This phenomenon is illustrated by many of the objects in this exhibition: Navajo wearing blankets or garments (43–45) gave way to rugs (48); Tlingit fruit-gathering baskets were miniaturized to become fancy baskets (26); wastebaskets were introduced for the first time into the Indian repertoire (3). Iroquois beadwork was applied to objects like stuffed birds and hanging boxes (116), which had an almost tour-de-force humor. Cochiti potters even fashioned figures that humorously depicted the non-Indian buyer (61).

Traders were directly responsible for some of the new Indian products from the Southwest. Many of the regional Navajo weaving styles (see 80, 81, 87, 89), for example, can be directly traced to individuals at specific trading posts who encouraged a degree of standardization and particular types of color combinations and design formats. Traditional Navajo textiles were borderless, but traders convinced weavers in many areas to work within a framed design field and even to add elaborate border detail. When traders brought oriental carpets to the weavers as desirable prototypes,[35] intricate forms such as the Teec Nos Pos style emerged. Traders in Navajo jewelry, similarly, encouraged the production of lightweight, stamped designs that could be produced relatively quickly and sold at moderate prices. They sometimes even specified what designs should be used. In order to meet the tourists' demand for "authenticity," the Harvey Company's Hermann Schweitzer even went so far as to compile a list of Indian symbols and to assign arbitrary meanings to them.[36]

Another factor in the collecting boom was the role the Indian items played in contemporary concepts of interior decoration. Articles and advertisements promulgating decorating with Indian baskets appeared in magazines such as *The Chatauguan* (1901) and *Country Life in America* (1903). Navajo rugs were similarly presented as "harmonious" and "proper" in *House Beautiful* (1898, 1902, 1909) and related periodicals.[37] Much of the impetus for this kind of decoration came from the design philosophy of the Arts and Crafts movement, whose proponents believed a well-designed environment would promote harmony and well-being. They favored handcrafted products that were made "honestly" with natural materials rather than machine-made items, and preferred simple, unadorned surfaces and geometric forms. The Arts and Crafts attitude took root in the United States, where it was embraced by a growing middle class that had little identification with older European styles. Its chief American spokesperson, Gustav Stickley, favored Indian objects, especially geometrically-patterned rugs and baskets, and assured readers of his monthly magazine, *The Craftsman*, that they were worthy of interest. He also included them in displays at the Craftsman Bazaar, his New York City showroom.[38]

The Arts and Crafts aesthetic permeated the culture in other, more subtle ways as well. J. B. Moore, the proprietor of the Crystal Trading Post on the Navajo Reservation, for example, identified strongly with Arts and Crafts principles. The designs he encouraged weavers in his area to develop were based on those principles, and since he catered to a large upper-middle class clientele,[39] his design ideas found their way into many American homes. Moreover, the decorative schemes of social leaders were often presented to the public as models to be emulated. A 1900 issue of the *Seattle Post-Intelligencer*, for example, illustrated the living room of prominent Seattle citizens Judge and Mrs. Thomas Burke. The "chief charm" of the room, according to the *Intelligencer*, was its "entirely Indian" interior decoration. The walls were "literally papered" with Indian baskets, plaques, matting, and blankets. "The varied colors found only in Indian work," were said to harmonize perfectly.[40]

Indian "corners" were also popular in turn-of-the-century homes. One corner of a room would be filled with Indian objects, including rugs, blankets, and pottery. "No home is complete nowadays without an . . . artistically arranged corner of this type," intoned Indian dealers and promotional literature from railroad companies and steamship lines.[41] Theme corners of this sort were also set up in other exotic styles (Turkish, Japanese, generic "cozy" corners), but the indigenous Indian corner was particularly popular in America, and it was perceived to be "masculine" enough to be used by men as well as women. Indian items were also considered appro-

priate for dens and boys' rooms.[42]

Turn-of-the-century collectors rushing to find Indian goods before they disappeared rarely acknowledged the discrepancy between their assumption and the burgeoning number of Indian goods being handled by traders and curio dealers. When they did, they tended to value only the older, "authentic" forms.[43] There was little exploration of the idea that there were new, experimental and often innovative forms in nearly all media, or that Indian art traditions were continuing to evolve. The general assumption, of course, was that there would soon be no more Indians. Indian products were not in any event perceived as art, but as ethnographic evidence of a "primitive" people, as travel mementos, or as utilitarian or decorative craft objects that could add to the quality of the environment. They were seen and valued as anonymous products made by "Indians" (or sometimes by "Navajo," "Washoe," or other tribes), rather than as creative works by individual artists. Most collectors had positive, even romantic feelings about the people who made the items, but they still did not see them as real, distinct, or individual people.

The Post-War Period:
Toward an Aesthetic Context

Most observers concur that the Indian collecting-craze was over by 1915.[44] During World War I, Americans were drawn more deeply into European and global concerns and the vanishing Indian was no longer felt to be a very pressing issue. Moreover, the devastation and cynicism generated by the war brought an end to old assumptions and beliefs and the nineteenth century's faith in cultural evolution began to fade. Anthropological inquiry moved from concern with cultural progress to interest in cultural centers and in the ways cultural traits might diffuse from one area to another. Ethnographers remained interested in Indian objects, less as remnants of disappearing cultures than as documentation of cultural process. They continued to collect and house objects in museums which, true to their Victorian origins, were institutions with a "natural history" focus.[45] Individuals interested in Indians and Indian objects might visit these museums, but they were relatively few in number, and they were not generally collectors. Articles about Indians largely disappeared from the popular press, and travel companies no longer highlighted Indians as part of their attractions. Indian corners and Arts and Crafts interiors were no longer fashionable.

Because the collecting craze had brought forth such an avalanche of Indian baskets, pots and other art forms, the objects did not really disappear. A new, quieter discussion of Indian art began to emerge in some parts of the art community. Esther

Coster, a china painter, was one of the first to use the phrase "American Indian art," at least in print. In 1916 Coster wrote an article addressed to art students touting the artisanry and inspirational value of American Indian objects. Both she and Walter Perry, the director of the School of Fine and Applied Arts at Pratt Institute who wrote an introduction to her article, appreciated the directness and refinement of the Indian work which they saw as expressions of "primitive art."[46] The concept of primitive art had been much discussed in Europe before this date, and the ethnographic monographs written by Mason and others had previously used this kind of terminology, but the emphasis on "art" rather than on "primitive" was relatively new in America at this time. The concern was with design analysis rather than vanishing people, and no cultural superiority was implied.

Herself a product of the Arts and Crafts movement, Coster was involved in the "decorative" arts, and her article focused on ways that needleworkers, printers, weavers, metalworkers, potters and other craftspeople might draw on Indian design ideas. This focus was repeated in a 1919 exhibition mounted at the Museum of Natural History.[47] This same interest in the ways modern design could draw on Indian art continued into the 1920s and beyond. The art was discussed apart from its cultural context, and was approached as decorative art or craft that was anonymous and technically interesting.

The mainstream culture even marketed expropriated Indian artforms. Instructions to craftswomen interested in "imitating" Indian baskets (they could use different materials that would produce faster results) had first appeared at the end of the turn-of-the-century collecting craze, and continued to be popular after World War I. "Apache" bead looms, similarly, were marketed with Indian-derived patterns by bead companies and retail stores.[48]

Beadwork techniques were also taught as part of "campcraft" to burgeoning numbers of Boy and Girl Scouts, Campfire Girls and other youth organizations. Indian lore and campcraft were considered enriching because they added "romance and color" (the romantic view was fostered by vanishing Indian sentimentality) to such groups.[49] The campcraft movement reinforced the stereotype of the "generic" Indian who produced anonymous craft, and trivialized Indian work by linking it to childhood and childish occupations. The association was carried over into the schoolroom. *School Arts* magazine had special Indian issues in both 1927 and 1931. Articles featured suggestions for classroom projects using images of Indians[50] and discussions of art curricula appropriate to Indian schools.[51]

Such discussions were important in another context; i.e., they reflected a movement that began

in the 1920s to save and revitalize Indian art within the Indian community. In 1922, a group of interested individuals founded an organization set up to preserve the "varied record of Indian arts of the Southwest." The group, incorporated as the Indian Arts Fund in 1925, not only collected older pieces, but encouraged and collected contemporary work as well.[52] Nineteen hundred and twenty-two also marked the beginning of the annual Santa Fe Indian Market, where artists could sell their work personally and where the work was presented as a living art form rather than as a curiosity or souvenir,[53] and the same year saw the first annual exhibition of Indian art at the Museum of New Mexico. The Denver Art Museum showed Indian art in 1925.[54] In the East, Indian art was shown at the Chatauguan Convention of the Federation of Women's Clubs. New York City citizens formed an Association on Indian Affairs, which had a counterpart in the West. These citizen groups were alarmed by the poor living conditions of the Indians, who, as a result of the Dawes Act, were rapidly losing their lands and who seemed to be losing their culture to successful assimilationist policies. More and more, the progressive attitude was shifting to a belief that Indians should be able to return to their tribal ways.[55] Thus interest in Indian art was once again linked to a concern for the Indian way of life.

Indians were encouraged to visit the new exhibitions in order to learn from products of their own past. "We cannot restore the lands we have taken from [the Indian]," intoned McKittrick in *School Arts*, "but we can restore to him his art tradition [and] awaken his pride in his own achievement."[56] This attitude also characterized the conclusions of a 1927 survey conducted by the Institute for Government Research: the Indian Office was advised to develop handcrafts in all Indian communities as a potential source of economic well-being and improved social conditions.[57] The late 1920s marked, then, the beginning of another "revival" of Indian art, especially in the Southwest.

New Deal Policies and Attitudes: Retribalization and "American" Indian Art

The social climate of the Depression—the same that extolled the virtues of artwork focusing on the "common" person, the "folk" that were the "salt of the earth"—fostered official encouragement of Indian art. Simultaneously, an appreciation of its aesthetic qualities began to develop, albeit in limited circles. An "Exposition of Indian Tribal Arts," sponsored by the privately-funded College Art Association, opened at the Grand Central Art Galleries in New York City in 1931, and travelled for two years thereafter. Though this Exposition was relatively small, the pieces (including weaving, pottery,

baskets, and painting, much of it contemporary) were carefully selected for their aesthetic value, and the exhibition was expected to "give thousands of white Americans their first chance to see really fine Indian work exhibited as art." Indians were presented as an innately artistic people who did not limit their artistry to things that would be put on shelves and whose conception of beauty led to art "in its broadest sense."[58] In their introduction to the Exposition publication, John Sloan, a painter, and Oliver La Farge, a Navajo artist/anthropologist, expressed hope for the future of Indian art. This attitude was reinforced that year by the Indian Bureau's "sympathetic understanding," and its sponsorship of a show of contemporary Indian work at the International Antiques Exposition. The Bureau also distributed a guide to Indian arts.[59] Further support came in 1932, when a program of formal training designed to integrate Western art techniques with traditions of the Indian past was started at the Santa Fe Indian School.[60]

One of the responses that emerged in the Depression period was that Indian art was distinctly *American*, and should be proudly embraced as part of the American heritage. Walter Pach, the art critic of the *New York Times*, expressed this sentiment in his review of the 1931 Exposition.[61] It was repeated in a 1932 article that claimed Indian art "springs from the very American soil itself and should be absorbed into the artistic expression of the country."[62] In 1933 and 1934, Southwestern Indians were hired by the Public Works Administration to paint and otherwise decorate schools, hospitals, and other buildings in the area.[63] It is significant that Indian work was deemed appropriate for funding at that time.

By 1934, the attitudes about Indian self-determination that had begun to take hold in the 1920s had captured public opinion, and the Indian Reorganization Act (officially, the Wheeler-Howard Act) was passed by Congress. This Act repealed the laws of the Dawes Act which had broken up tribal governments by allotting land to individuals and allowed reservation lands to shrink through individual sales. Under the Reorganization Act, residents of reservations could opt to incorporate and again be dealt with as tribal units. As such they could acquire additional land and help provide new jobs and educational opportunities for their members. Freedom of religion was also officially restored, and a revival of traditional cultural activities was encouraged. Assimilation was still assumed ultimately to be inevitable, but government policies that worked toward that end were essentially eliminated.[64]

Arts programs began to be seen as an integral part of Indian cultural revival. According to one Indian historian, the renewed right to cultural expression brought forth an "amazing outpouring" of Indian painting and sculpture,[65] and for its part,

the government established the Indian Arts and Crafts Board as an official arm of the Bureau of Indian Affairs in 1935.[66] The Board worked to ensure high standards in contemporary Indian work and to help find an appreciative audience. Its director, Rene d'Harnoncourt, recognized several markets. He noted that Indians were themselves interested in Indian art, as such art was increasingly appreciated as an expression of tribal identity, and he tried to encourage them to explore their traditions as part of their cultural revitalization. The focus of the agency, however, was not on historic authenticity or revivalism, but on adapting to the contemporary context. A small but serious collector's market, interested in high-priced showpieces, was acknowledged and encouraged, for although it would directly benefit only a handful of Indian artists, it was believed to have a trickle-down effect. However, the primary focus was the casual buyer. Good quality but inexpensive household or decorative accessories could have a broad appeal. D'Harnoncourt reasoned that the public would best come to appreciate the aesthetic quality and intrinsic value of Indian work if they could integrate it into their own lifestyle and familiar setting. A major exhibition staged by the agency in 1939 at the Golden Gate International Exhibition (San Francisco World's Fair) explored this "decorative" theme.[67] In sum, the Indian Arts and Crafts Board was true to its name in that it primarily presented Indian work in a "craft" context.

Entering the Art Museum

Some serious efforts to go beyond the decorative arts categorization were made. George Vaillant, who published *Indian Arts in North America* in 1939, explained that, inspired by d'Harnoncourt to document the artistic achievements of Native Americans, he had received Rockefeller Foundation funding to survey the field. He hoped to present Indian art in an aesthetic context, as art, and to help the public to see it in a new way. Noting that the articles on Indian aesthetics published at the time of the 1931 Exposition had not reached a wide audience and were already almost impossible to find, Vaillant claimed that Americans had no fully illustrated "reference book" on North American Indian art. He acknowledged that there was an Indian aesthetic that he himself was only partially able to comprehend (the "impenetrable clouds of white domination" prevented non-Indian people from seeing it clearly), but he intuited its depth and importance.[68]

At approximately the same time that Vaillant was working on this project, a group was incorporated to form a "National Gallery of the American Indian." The proposed museum, which never became a reality, was to provide a study collection for both white and Indian artists, and to "help the white man regain contact with [the Indian's] natural balance and poise."[69] In 1940, the Philbrook Art Center in Tulsa, Oklahoma began displaying Indian art objects in an aesthetic context.[70] In 1941, d'Harnoncourt and Frederic Douglas organized a major exhibition that filled the entire gallery space of the Museum of Modern Art with Indian works. *Indian Art of the United States* constituted the first full-scale exhibition of Indian art in a major American art museum.

The MOMA show, which attempted to give Indian art its due and erase its association with mere technical achievement or cheap curios, was divided into three parts. One gallery featured prehistoric art. A second showed art of "living Indian cultures," and a third focused on the contribution of Indian art to the contemporary American scene. The latter section was based on the same patriotic sentiment that had been prevalent a decade earlier (see p. 9), but was reinforced at this time by the national introspection brought on by the European war. The public was interested in all things that were "truly American" and d'Harnoncourt wove that theme into his presentation. He spoke of the work as "folk" rather than "primitive" art.[71]

Indian Art in the United States marked the pinnacle of the achievement and activity of d'Harnoncourt and, by association, the Indian Arts and Crafts Board.[72] The Board's budget was drastically cut in 1942 under a war-time economy, and as support for the New Deal waned in the new war-time cultural climate, the newly-gained popular appeal of Indian art was largely lost. At that time many Indians left their reservations to join the armed forces or work in the war industries, and there was a new mixing of Indian and non-Indian populations. The number of productive Indian artists decreased dramatically.[73] Sadly, the cyclical wheel of American attitudes toward Indians had turned again, and the concept of assimilation was revived. In the generally conservative, suspicious climate of the 1950s, official Indian policy again focused on terminating tribal governments and revitalizing the Reorganization Act.[74] Some decorative arts and crafts themes continued in a muted fashion,[75] and there were some other signs of interest (a few studies of specific aspects of Indian art were published in the post-war decade; the Philbrook Art Center instituted an annual competitive exhibit; and the Institute of American Indian Arts, an Indian school, was opened in Santa Fe),[76] but the public at large felt a general disdain for difference and for anything Indian (this was the era of the cowboy-and-Indian television show), and Indian art seemed again to be fading away.

The Re-Discovery of Indian Art: The Second Collecting Boom

This appearance was to be proven very wrong. By the late 1960s there was a resurgence of interest in Indian art, and a new burst of activity on the part of Indian artists. The same pots, beadwork, and similar items that had been seen in turn as curiosities, ethnological evidence, souvenirs, and decorative handicraft, furthermore began to be more generally appreciated as artworks.

The 1960s was an expansive decade in many senses, one in which the cultural and political imperialism of Western society began to break down. It was a time when old definitions and assumptions were questioned. Indians, like other minority groups in America, began to vocally reclaim their cultural heritage and demand their right to self-determination. The first expression of this was perhaps the American Indian Chicago Conference of 1961,[77] but the movement grew with the rising tide of other civil rights protests and was symbolized by the American Indian Movement that flourished ten years later. When the near-dormant Indian Arts and Crafts Board came to life again in 1967 with a display at the Montreal World's Fair,[78] it was a sign of the times.

In this atmosphere of cultural pluralism, many expressions of non-Western traditions began to make their way into the dominant culture and to have an impact upon it. On a popular level, fashions incorporated such elements as the "Afro" hairdo, the Nehru jacket, the dashiki, and the Indian headband, and ethnic traditions like African tie-dye and Indonesian batik became overnight fads. "Counterculture" advocates who were dissatisfied with the supremacist Cold War mentality that had engendered the Vietnam War looked to minority ethnic cultures for more acceptable models, embracing not only their external trappings but their underlying philosophies. Once again the Indian lifestyle was of interest to large groups of outsiders, but this time as a model of holistic, harmonious existence rather than as a curiosity or a reinforcement of already-held beliefs. It was the spiritual dimension of Indian life that was beginning to be appreciated, and with it came a new appreciation and understanding of Indian art.

Other factors came together at the same time to facilitate this new apprehension. In the art world, non-western works found a large audience. "Primitive" art had first had an impact on western artists at the turn of the century, but the general public remained unaware of its forms and traditions, and did not yet think of it as real art. In the 1960s, with the emergence of new, independent African countries and the Black ethnic pride movement in America, there was a new interest and reevaluation of African art, more and more of which began to be shown in art museums and galleries. A concomitant "discovery" of the arts of Oceania and the Pacific followed. A wealth of imagery and concepts was opened to the public. Just as non-western elements were incorporated into the vocabulary of western fashion, so too were "primitive" elements consciously incorporated into the vocabulary of modern western art. "Primitive" became a positive adjective, and modernists who used primitive elements in their work were seen as direct, strong, and powerful.[79] There was a new framework, then, within which American Indian art could be viewed. Once this was in place, it had an accelerating effect, for as Indian-made objects began to be seen more and more in the context of art museums and galleries, they were increasingly felt to belong there. The ideas expressed by a few pioneering individuals in the 1930s and 40s had finally made their way into the mainstream by about 1970.[80]

The late 1960s and early 70s also gave rise to a renewed appreciation for crafts of all kinds. Inspired in part by non-western art forms, western artists began to explore clay, fiber, wood, and related media in new ways, and to challenge the dichotomy between art and craft. Handmade items of all kinds were valued, but they were no longer seen as strictly decorative.[81] This craft explosion was reinforced by a renewed scholarly and popular attention to folk art, seen at this point less as Americana or a manifestation of the rural or working class than as yet another legitimate but undervalued form of artistic expression.[82] This perception was in turn reinforced or informed by the feminist interest in reclaiming the art of unsung generations of "anonymous" women (this was especially apparent in the reclaiming of the American quilt tradition), and by their redefinition of what should be understood as "legitimate" art.[83] Changing attitudes were also evident in the anthropological community. Assumptions about acculturation and diffusion began to be questioned, and there was a new academic acceptance of cultural pluralism.

As these forces came together, American Indian art became a valued—indeed a "hot"—commodity. The turning point was 1970–71,[84] when prices of Indian objects began to increase rapidly. The first big jump was noted at the auction of the Birdie Brown estate in Phoenix, Arizona in 1970. The estate included a collection of over 1400 Chemehuevi baskets for which buyers were willing to spend significant sums. The *Indian Trader,* a newsletter devoted to the trading and collecting of American Indian art, also appeared in that year. In 1971, the New York auction house Parke-Bernet auctioned the George Green Collection (see 6, 12), realizing unheard-of prices for American Indian items, including over $6000 for a single basket. Another estate realized $450,000, twice its appraised value, for its Indian art in 1974.[85]

American Indian Art, a quarterly whose stated purpose was "to portray the art forms of the American Indian in a manner and format which will do justice to the art and its creators,"[86] began publication in 1975. The magazine, which published scholarly essays on many aspects of historic and contemporary art, was well designed, colorful, and eye-catching. From its inception it was—and it remains—a focal point for individuals with both scholarly and collecting interests. With its introduction, the subject of American Indian art was fully legitimized and had come of age.

The Contemporary Scene

The trends that started in the early 1970s have continued unabated. The public has had more and more opportunity to become aware of Indian art, as there have been a plethora of thoughtful, well-illustrated books and museum exhibitions in both North America and other parts of the world. Like the groundbreaking 1941 MOMA show, many of the exhibitions have been held in art museums, and have included the phrase "Native American Art" or "American Indian Art" in their titles. Even exhibitions in natural history museums now reflect a new aesthetic awareness.[87] In 1977, the Art Institute of Chicago mounted a large scale, comprehensive exhibition that expressly took an "art historical approach" to Indian art,[88] and the Native American Art Studies Association, an organization made up of art historians, anthropologists and collectors, was formed in 1977.

The focus on functional arts and crafts and interior design that prevailed at the turn of the century and even in d'Harnoncourt's exhibitions of the 1930s is no longer a major concern. This is evident again in terminology and titles—Frederick Dockstader went from *Indian Art in North America: Arts and Crafts* in 1960 to simply *Indian Arts of the Americas* in 1973—and in the types of objects that are being produced. Navajo sale weavings are now often made as tapestries rather than rugs; that is, they are made in smaller sizes and with finer yarns (see for example 87, 89) and are not conducive to floor use. They are typically now hung on walls rather than used as rugs.

Hand in hand with the new perception of Indian works as art has come the recognition that these are not anonymous products made by faceless people, but recognizable individual works, created by nameable artists. This new apprehension has had an enormous impact on the contemporary Indian art scene and on contemporary Indian artists. "Masters" have been acknowledged, not just within the Indian community, but by the world at large; the non-Indian public has created "stars" whose work is widely publicized and in great demand. Although

some white entrepreneurs were encouraging Indian artists to sign their work as early as 1925,[89] it was not until this new conception of Indian art was prevalent that signatures or artist's marks became common on pots, jewelry, and other ostensibly functional forms.[90] Distinctive personal styles, even within traditional forms, have also been supported and reinforced by this new context and market. Whereas in the past it was the "old," "authentic" items seen as remnants of a dying culture that were in demand, there is now strong interest in the kind of innovative work that fits the still-dominant western concept of art.[91]

Some of the emphasis on personal innovation has come from the artists themselves. The members of the emerging younger generation of Indian artists had to a large extent attended mainstream American schools and were brought up as bi-cultural individuals; western attitudes and ideas were not foreign, but were as much or more a part of them as Indian attitudes and traditions. Many of these individuals rejected "Indian" media and techniques, and went outside or beyond Indian or ethnic themes in their work. They are Indian artists, in other words, who produce "mainstream art."[92] Others blend Indian and non-Indian elements. They may work in a European painting or sculpture tradition, for example, while making reference to Indian conditions or drawing upon an Indian world view (93). Still others stay within Indian traditions but find new freedom to experiment and expand upon them, and take them in new, unexpected directions (33–36, 99, 105).

These varied directions of contemporary Indian art have created a dilemma for many Indian artists, who find themselves confronting the question of whether their work should reflect their tribal heritage and a communal aesthetic or the expressive individualism of the non-Indian world. Even mainstream-oriented artists who wish to retain their Native American identity are perceived as "different," for their ethnicity is the best promotion for their work.[93]

The same varied artistic directions have meant a wide field of possibilities for the collector. Today a broad range of forms falls under the rubric of "Indian art." This inclusiveness was reflected by the statement of intent of the first issue of *American Indian Art,* which begged the question of definition by saying it was concerned with the "wide variety of attractive material forms, prehistoric to contemporary, that Indians produce[d]." Art collectors now sometimes focus on the objects that were once seen as ethnological specimens and collected by natural history museums, and such items command enormous prices on the international art market. Even when there was a major recession in the market in 1982, *American Indian Art* reported that the type of work they were concerned with was not seriously

affected.[94] Exceptional old pieces, such as Navajo Chief's blankets, have recently even sold for as much as $35,000, and one beaded Plains shirt went for nearly twice that figure.[95] Continually updated editions of collector's price guides first appeared in 1978. The very fact that there is such a market has meant that more and more old pieces have been brought out of family attics and other storage places and have been made available to the public.[96] The availability has in turn stimulated new collections and suggested new directions for existing ones. As a case in point, in the early 1980s there were several museum exhibitions of private collections that had begun to be assembled only ten years before.[97]

There is also an audience for contemporary Indian work, and other collectors focus almost exclusively on the work of living artists (in this exhibition, see the Busse and Hootkin collections). Individual collectors have the opportunity to support a particular kind of ongoing art form (see the Busse collection) or a particular individual artist (see Van Zelst 33–36; Hootkin 94–96, 102–104; Cusick 52, 53, 58, 59) and even to establish an artist/patron relationship. Both traditional and more individualistic contemporary art is collected, although not always by the same individuals. *Four Winds,* a publication that existed briefly between 1980 and 1982, focused almost entirely on named Indian artists.

For the first time Indian art is being seriously appreciated and collected for what can only be referred to as its spiritual quality and meaning. This is true, although in different ways, for both Indians and non-Indians. Many native people have themselves turned to Indian art as an expression of a direct, tangible manifestation of the Indian world view and Indian spirit. When resources are available, some Indians have begun collections of their own, sometimes concentrating on examples of their own tribal background (see Smith collection), and sometimes more broadly embracing the whole gamut of North American Indian life. Some of these individuals had earlier eschewed their ethnic background or had not grown up in an Indian context, and found in the objects a way back to their own native roots. Others had been strongly identified as "Indian" all their lives, but chose to go deeper into that identity and to share it with others.[98] Indian organizations such as tribal councils have also shown an interest in the preservation and display of such objects. There are currently forty-eight tribal museums in North America.[99]

The spiritual dimension has permeated the mainstream culture as well, however, and has affected the way Indian art is perceived. In recent years American Indian art exhibitions have carried titles such as "Sacred Circles," "Song From the Earth," "One With the Earth" (1976), "Pleasing the Spirits" (1982), "As In a Vision" (1983), and "The Raven's Journey" (1986). The underlying theme is that this work is not just interesting or visually pleasing, but is the embodiment of a way of relating to the earth and the invisible world; it is art, but an art that cannot be separated from either life or the spirit. Sometimes it is even seen as superior to western art. John Gogol voiced this sentiment in 1984 when he stated, "art in contemporary [western] society is insipid, weak, frivolous, mere decor. In tribal societies artists were . . . in harmony with their environment . . . [and] art was powerful and spiritual, a moral imperative."[100] This feeling, which is almost a total reversal of earlier attitudes, was as stated, briefly expressed in about 1940 and manifested more strongly in the 1960s, but it has now grown beyond its minority or counterculture origins and has colored the apprehension of Indian objects of all kinds.

What of the future? How will Indian art be perceived, and what will happen to Indian art collecting? Since there have been periods when Indian art was fashionable and periods when it was not, and there have been cycles in government policy and in the way Indians are treated, could the current acceptance and popularity of Indian art fade once again?

Popular taste and aesthetic values are hard to predict, of course, but it seems likely that Indian work has become a permanent part of the western art vocabulary, and that it will not be easily dismissed in the future. Definitions of art have broadened considerably in the last two decades, and as we have seen, western and non-western art traditions have in general come closer and closer together. We are now at a point where Indian artists work in European styles and vice versa. The sentiment of the 1960s that western art is sterile and empty does not ring as true today, for the tradition has incorporated, at least in the case of certain artists, many of the strengths of the art of ethnic peoples. The fact that Indian artists, even those working in traditional techniques such as pottery-making and weaving, are now signing their work also makes it easier for non-Indians to accept that theirs is more than an anonymous craft.

The popular recognition of distinct Indian artists has helped change the perception of Indians and Indian art. We have seen that Indians were always felt to be "other" or "different." While this attitude and its inherent racism are sadly not completely a thing of the past, the multicultural realities of present-day America and the shrinking world community make it more and more difficult to maintain colonialist attitudes. There is an increasing recognition that there are all kinds of American Indians, just as there are all kinds of people in general. This recognition is reinforced and furthered by the publicity afforded individual Indian artists, and by every new book, catalogue or newspaper story that deals with Indian art. As Indians—Indian individ-

uals and Indians as a people—are seen more clearly, their art is understood more completely. As the distance between Indians and non-Indians decreases (and we are referring to a coming-together, not the assimilation of one group into the other), it is unlikely that Indian art will ever again be ignored or easily dismissed.

Notes

1. The concept of psychic energy invested in objects is explored in Mihaly Csikszentmalyi and Eugene Rochberg-Halton, *The Meaning of Things: Domestic Symbols and the Self* (New York: Cambridge University Press, 1981).

2. The term "American Indian" can, of course, rightfully include native peoples of Central and South America. All of the collections represented here are limited to the work of native peoples of North America, however, and most North Americans use the term in a peculiarly ethnocentric context. This terminology and the attitude it reflects are shaped by historical definitions and events.

3. See Ruth L. Bunzel, *The Pueblo Potter: A Study in Creative Imagination in Primitive Art* (New York: Columbia University Contributions to Anthropology 8, 1929); Lila O'Neale, *Yurok-Karok Basket Weavers* (University of California Publications in American Archeology and Ethnology 32 [Berkeley: University of California Press, 1932]).

4. See Frederick J. Dockstader, *Indian Art of the Americas* (New York: Museum of the American Indian, Heye Foundation, 1973), p. 10; James Howard, "Birch Bark and Paper Cutouts from the Northern Woodlands and Prairie Border," *American Indian Art* 5, 4 (Autumn 1980): 54–61.

5. Evan M. Maurer, "Determining Quality in Native American Art," in Edwin L. Wade, ed., *The Arts of the North American Indian: Native Traditions in Evolution* (New York: Hudson Hills Press, 1986), p. 144; Lloyd Kiva New, "Feathers or Freedom: An Essay on the Dynamics of American Indian Arts," *Craft International* (July–September 1987): 12.

6. Gary Witherspoon, *Language and Art in the Navajo Universe* (Ann Arbor: University of Michigan Press, 1977), p. 23, pp. 151–152.

7. Evan M. Maurer, *The Native American Heritage: A Survey of North American Indian Art* (Chicago: The Art Institute of Chicago, 1977), p. 17.

8. Nicholas Denys, "The Description and Natural History of the Coasts of North America," in H. F. McGee, *The Native Peoples of Atlantic Canada: A Reader in Regional Ethnic Relations* (Toronto: McClelland and Stewart, 1974), p.42; Wilson D. Wallis and Ruth Sawtell Wallis, *The Micmac Indians of Eastern Canada* (Minneapolis: University of Minnesota Press, 1955), p. 89; Douglas Cole, *Captured Heritage: The Scramble for Northwest Coast Artifacts* (Seattle: University of Washington Press, 1985), pp. 1–2.

9. Ruth B. Phillips, *Patterns of Power: The Jasper Grant Collection and Great Lakes Indian Art of the Early Nineteenth Century* (Kleinburg, Ontario: The McMichael Canadian Collection, 1984), pp. 12–19.

10. Charles Wilson Peale opened a cabinet (museum) in Philadelphia in 1785; a group of sea captains opened one in Salem, Massachusetts in 1799. The latter later became known as the Essex Institute. See Joan Lester, "The American Indian: A Museum's Eye View," *The Indian Historian* 5, 2

(Summer 1972): 25–31; Maurer, p. 17; Mary Malloy, "Souvenirs of the Fur Trade, 1799–1832," *American Indian Art* 11, 4 (Autumn 1986): 30.

11. See Norman Feder, *American Indian Art* (New York: Harry N. Abrams, 1971), pp. 10–11.

12. James Axtell, *The European and the Indian: Essays in the Ethnohistory of Colonial North America* (New York: Oxford Press, 1981), p. 315; Nancy B. Black and Bette S. Weidman, eds. *White on Red: Images of the American Indian,* Port Washington (New York: Kennikat Press, 1976).

13. Laura Schrager Fishman, *How Noble the Savage? The Image of the American Indian in French and English Travel Documents, ca. 1550–1680*, Ph.D. dissertation, City University of New York, 1979, pp. 10 and 430; Black and Weidman, Introduction; Robert F. Berkhofer, Jr. *The White Man's Indian: Images of the American Indian from Columbus to the Present* (New York: Alfred A. Knopf, 1978), pp. 28–30.

14. "Catlin's North American Indians" [Review of Catlin's *Letters and Notes on the Manners, Customs and Conditions of the North American Indians*] in the *United States Magazine and Democratic Review* 11, 49 (July 1842): 44–52.

15. Nancy B. Black "The Red Man of America," in Black and Weidman, p. 285.

16. Lester, pp. 26–27; John C. Ewers, "The Emergence of the Plains Indian as a Symbol of the North American Indian," in Roger L. Nichols, ed. *The American Indian: Past and Present* (New York: John Wiley and Sons, 1971, 1980), p. 5.

17. "Catlin's North American Indians," pp. 49, 52.

18. John C. Ewers, "Artist's Choices," *American Indian Art* 7, 2 (Spring 1987): 41–49.

19. Richard Rose, "The Morgan Collection at the Rochester Museum and Science Center," *American Indian Art* 12, 3 (Summer 1987): 32–37.

20. Lester, p. 28.

21. Brian William Dippie, *The Vanishing American: Popular Attitudes and American Indian Policy in the Nineteenth Century.* Ph.D. dissertation, University of Texas, 1970; Francis Paul Prucha, William T. Hagar, and Alvin M. Josephy, Jr., *American Indian Policy* (Indianapolis: Indiana Historical Society, 1971), p. 42; Graham D. Taylor, *The New Deal and American Indian Tribalism: The Administration of the Indian Reorganization Act, 1934–1935* (Lincoln: University of Nebraska Press, 1980), pp. 4–5.

In actuality, the concept of the vanishing Indian emerged much earlier in the century; even Catlin was "lending a helping hand to a dying race." The concept took on new meaning and had a powerful effect on the popular imagination after 1880, however, and in the context of this discussion it is appropriate to treat it as an end of the century phenomenon.

22. The Field Museum of Natural History was itself established to permanently house the artifacts that had been amassed for display at the World's Columbian Exposition in 1893. This fair and others like it in the turn-of-the-century period can be credited with some of the first presentations of Indians and Indian objects in personal settings—in family and community groups, performing everyday tasks, etc. The fairs helped stimulate interest in Indian lifeways and contributed strongly to the collecting boom. (See Lester, pp. 30–31.)

23. Zena Pearlstone Mathews, *Color and Shape in American Indian Art* (New York: Metropolitan Museum of Art, 1983), p. 18; Phyllis Rabineau, "North American Anthropology at the Field Museum of Natural History," *American Indian Art* 6, 14 (Autumn 1981): 31–37, 79.

24. A. I. Hallowell, "The Backwash of the Frontier: The Impact of the Indian on American Culture," in Walker D.

Wyman and C. B. Kroeber, eds., *The Frontier in Perspective* (Madison: University of Wisconsin Press, 1957), p. 253.

25. Set number 21R242, p. 147.

26. Prucha, p. 217.

27. Prucha, p. 217; Richard Conn, *Native American Art in the Denver Art Museum* (Denver: Denver Art Museum, 1979), p. 25.

28. It is ironic that Ramona, the heroine of the novel, was portrayed as a thoroughly Christianized Indian who no longer lived in a traditional lifestyle.

29. Frank Stefano, Jr., *Pictorial Souvenirs and Commemoratives of North America.* (New York: E. P. Dutton, 1976), p. 22; George Miller and Dorothy Miller, *Picture Postcards in the United States.* (New York: Crown, 1976), p. 15.

At least one observer feels that the cards published in the first decade of the twentieth century have become one of the prime sources of knowledge of the Indian culture of the period. See John M. Gogol, "1900–1910, The Golden Decade of Collecting Indian Basketry," *American Indian Basketry and Other Native Arts* 5, 1 (April 1985): 28.

30. See Margarey B. Blackman, "Posing the American Indian," *Natural History* (October 1980): 70–74.

31. Gogol, pp. 16–17; Sarah Rath, *Pioneer Photographer: Wisconsin's H. H. Bennett* (Madison: Tamarack Press, 1979); Beverly Gordon, *The Niagara Falls Whimsey: The Object as a Symbol of Cultural Interface.* Ph.D. dissertation, University of Wisconsin, 1984.

32. A. J. Burkart and S. Medlik, *Tourism: Past, Present and Future* (London: Heinemann, 1974).

33. Henry B. Harrington, "Condition of Indians—New York," in "Report on Indians Taxed and Not Taxed in the United States," *Eleventh Census of the United States, 1890* (Washington: Government Printing Office, 1894), p. 481; Carrie A. Lyford, *Iroquois Crafts* (Washington: United States Department of the Interior, Indian Handicrafts Series 6, 1945), p. 74.

34. J. J. Brody, *Indian Painters and White Patrons.* (Albuquerque: University of New Mexico Press, 1971), p. 61.

35. Brody, p. 63.

36. Mark Bahti, *Collecting Southwestern Native American Jewelry* (New York: David McKay, 1980), pp. 38–41.

37. George Wharton James, "Indian Baskets in House Decoration," *The Chautauguan* 33 (1901): 619; Charles Otto Thieme, "Collecting Navajo Weaving," in Otto Thieme, Ruth E. Franzen and Sally G. Kabat, eds., *Collecting Navajo Weaving* (Minneapolis: Goldstein Gallery, University of Minnesota, 1984), pp. 2–3.

38. Thieme, p. 2.

39. Brody, p. 63.

40. Gogol, pp. 25–27.

41. Gogol, pp. 16–17.

42. Thieme, p. 3.

43. Torrey Connor, "Confessions of a Basket Collector," *Land of Sunshine*, June 1896, reprinted in *The Indian Trader* 3, 2 (February 1972): 4.

44. Gogol, p. 29.

45. Some new institutions also opened in the post-war period, including the Heard Museum, which began as the repository of another private collection of Indian artifacts. See Patrick T. Houlihan and Barbara Cartright, "The Heard Museum," *American Indian Art* 4, 2 (Spring 1979): 32–39, 85.

46. Esther A. Coster, "Decorative Value of American Indian Art," *The American Museum Journal* (American Museum of Natural History) 16, 1 (May 1916): 301–307.

47. George C. Vaillant, *Indian Arts in North America* (New York: Harper and Borthers, 1939), p. 2.

48. John M. Gogol, pp. 27–28; see for example Allen's Boston Bead Store catalogue, 1920.

49. Julian Harris Salomon, *The Book of Indian Crafts and Indian Lore* (New York: Harper and Brothers, 1928), p. xiv.

The Campfire Girl prototype was, in fact a charming Indian maiden who stayed home and kept the home fires burning. See Charles E. Strickland, "Juliette Low, The Girl Scouts, and the Role of American Women," in Mary Kelley, ed. *Woman's Being, Woman's Place: Female Identity and Vocation in American History* (Boston: Greek Hall, 1979), p. 259.

50. Beula Mary Wadsworth, "The Indian as a Block Print Motif for a School Annual," *School Arts* 27, 3 (November 1927): 151–154.

51. Kenneth M. Chapman, "Indian Arts for Indian Schools," *School Arts* 27, 3 (November 1927): 131–138; Homer L. Morrison, "Schools for the Indian Children," *School Arts* 27, 3 (November 1927): 149+; Margaret McKittrick, "Lost: A Tradition," *School Arts* 30, 7 (March 1931): 449–453.

52. Arthur H. Wolf, "The Indian Arts Fund Collection at the School of American Research," *American Indian Art* 4, 1 (Winter 1978): 32–37.

53. Sally M. Kandarian and Helen Hardin, "Indian Market at Santa Fe," *American Indian Art* 1, 4 (Autumn 1976): 32–33, 58–59.

54. Christian F. Feest, *Native Arts of North America* (New York: Oxford University Press, 1980).

55. Robert Fay Schrader, *The Indian Arts and Crafts Board: An Aspect of New Deal Indian Policy* (Albuquerque: University of New Mexico Press, 1983), p. 13.

56. McKittrick, p. 450.

57. Schrader, pp. 18–19.

58. John Sloan and Oliver LaFarge, *Introduction to American Indian Art* (New York: The Exposition of Indian Tribal Arts, 1931), pp. 51–52.

59. Schrader, p. 49.

60. Brody, p. 190.

61. Schrader, p. 50.

62. Herbert W. Kuhm, "The Art of the American Indian," *Wisconsin Archeologist* 12, 1 (October 1931): 21–25.

63. Schrader, p. 118.

64. Alvin M. Josephy, Jr., "Toward Freedom: The American Indian in the Twentieth Century," in Francis Paul Prucha, William T. Hagan and Alvin M. Josephy, Jr. *American Indian Policy* (Indiana: Indiana Historical Society, 1971), pp. 44–52; Taylor, pp. 22–29.

65. Jamake Highwater, *The Sweet Grass Lives On* (New York: Lippincott and Crowell, 1980), p. 21.

66. Schrader, p. 118. The perceived relationship between the arts and traditional Indian life was reflected in the title of a book that was published in 1936, H. Kolshorn Burton's *The Re-establishment of Indian Arts in Their Pueblo Life Through the Revival of Their Traditional Crafts.*

67. Schrader, pp. 144–173.

68. Vaillant, pp. xi-6. Vaillant's sentiment was perhaps one of the earliest articulations of what later came to be known as *ethnoaesthetics.*

69. "National Gallery of the American Indian," pamphlet, New York, c. 1940.

70. John A. Mahey, *Native American Art at Philbrook* (Tulsa: Philbrook Art Center, 1980).

71. Frederick H. Douglas and Rene' d'Harnoncourt, *Indian Art in the United States* (New York: Museum of Modern Art, 1941); Schrader, pp. 223–240; Mathews, p. 18.

72. It should be noted that there was a series of scholarly publications apparently sponsored by the Board during the 1930s and 40s. The Indian Handcraft Series was printed by Indian students in the vocational education program of Haskell Indian Junior College in Lawrence, Kansas.

73. Schrader, pp. 240–241.

74. Schrader, p. 241, Josephy, pp. 59–62.

75. "Beautiful and useful home furnishings" such as lamp bases, cigarette holders, and plant holders were the focus of "So You Want to Buy Some Pueblo Pottery," *Indian Life: The Magazine of the Intertribal Indian Ceremonial* 40, 1 (August 1961): 12.

76. Jamake Highwater, *Song from the Earth: American Indian Painting* (New York: New York Graphic Society, 1976); Feder, p. 22; New, p. 13.

77. Josephy, p. 60.

78. Schrader, p. 241.

79. Robert Goldwater's *Primitivism in Modern Art* (New York: Vintage Books, 1967) describes the process by which "primitive art"—in this case referring to artifacts of all "primitive cultures"—came to be reassessed as art at this time.

80. The puzzlement and still-equivocating attitude of the early 1960s was addressed in a speech art historian Robert Redfield made to an audience looking at "primitive" art in a western aesthetic context. The speech was printed as "Art and Icon" in Charlotte Otten, ed. *Anthropology and Art: Readings in Cross Cultural Aesthetics* (Garden City, New York: Natural History Press, 1971), pp. 39–67.

81. For an understanding of how this shift in perception took place in one medium, see Ruth Kaufman, *The New American Tapestry* (New York: Chapman-Reinhold, 1968) and Mildred Constantine and Jack Lenor Larsen, *Beyond Craft: The Art Fabric* (New York: Van Nostrand Reinhold, 1974).

82. Examples of works that came out in this period that expressed this view are Jean Lippman and Alice Winchester, *The Flowering of American Folk Art 1776–1876* (New York: Viking Press and Whitney Museum of Art, 1974); Herbert Hemphill, Jr. and Julia Weissman, *Twentieth Century American Folk Art and Artists* (New York: E. P. Dutton, 1974). The word "primitive" was also, of course, applied to folk art.

83. See for example Patricia Maindardi, *Quilts: The Great American Art* (San Pedro: Miles and Weir, 1978; originally in *Feminist Art Journal* [Winter 1973]); see also Rozsika Parker and Griselda Pollock, *Old Mistresses: Women, Art and Ideology* (New York: Pantheon Books, 1981) for an excellent analysis of the art/craft dichotomization and the recovery of women's art traditions.

84. Interestingly, this coincided once again with a change or reversal in government policy. Self-determination of Indian people was reestablished in some senses in 1971. See Josephy, p. 65.

85. Harmen Johnson, "The Auction Block," *American Indian Art* 1, 1 (Autumn 1975): 18; Douglas Ewing, *Pleasing the Spirits: A Catalogue of a Collection of American Indian Art* (New York: Ghylen Press, 1982), p. 9.

86. Editorial, *American Indian Art* 1, 1.

87. Cole, p. 290.

88. This was stated by the curator, Evan Maurer. See Maurer, *The Native American Heritage.*

89. Brody, p. 68.

90. Artist's marks are still an evolving issue. The inclusion or exclusion of signatures or other marks varies a great deal according to art form and locale—baskets are for example rarely signed, but pottery now usually is, and signatures are more common in the Southwest and Northwest coast than in the Woodlands area. Entrepreneurs also still have an impact. For the last few years the Hubbell Trading Post has required that all Navajo rugs they sell must have signatures woven in the design, and weavers who did not include them before have begun to do so.

91. The first major recognition of the individualist trend in Indian art was probably the publication of *Art and Indian Individualists: The Art of Seventeen Contemporary Southwest Artists and Craftsmen* by Guy and Doris Monthan (Flagstaff: Northland Press, 1975).

92. Feest, p. 16; Nelson Graburn, Intro., *Ethnic and Tourist Arts: Cultural Expressions From the Fourth World* (Berkeley: University of California Press, 1976); Edwin H. Wade, "The Ethnic Art Market in the American Southwest 1880–1980," in George W. Stocking, Jr., ed. *Objects and Others: Essays on Museums and Material Culture* (Madison: University of Wisconsin Press, 1985), pp. 187–189.

93. Helen Giambruni, "Editorial: The Native American Dilemma," *Craft International* (July–September 1987): 5; Edwin L. Wade, *The Arts of the North American Indian: Native Traditions in Evolution* (New York: Hudson Hills, 1986), or "The Ethnic Art Market," p. 189. The dilemma Giamburni names is also reflected in a recent touring exhibition entitled "What is Native American Art?"

94. Harmer Johnson, "Auction Block," *American Indian Art* 7, 4 (Autumn 1982): 18.

95. Harmer Johnson, "Auction Block," *American Indian Art* 12, 3 (Summer 1987): 18, and *American Indian Art* 12, 1 (Winter 1986): 13.

96. Ewing, pp. 9–11. This is not to imply that there is an infinite supply of old pieces. It means that the same pieces that were collected for other reasons in the past are recirculating for new reasons now.

97. Edwin H. Wade, Carol Haralson and Rennard Strickland, *As in a Vision: Masterworks of American Indian Art: The Elizabeth Cole Butler Collection at Philbrook Art Center* (Norman: University of Oklahoma Press, 1983); Jean Blodgett, *Grasp Tight the Old Ways: Selections from the Klamer Family Collection of Inuit Art* (Toronto: Art Gallery of Toronto, 1983); Ewing, *Pleasing the Spirits*, 1982; *Of Pride and Spirit: North American Indian Art From a Private Collection in Hawaii* (Honolulu: Honolulu Academy of Arts, 1981).

98. For example, Elizabeth Cole Butler, a woman of Choctaw heritage, assembled a collection of over 2000 examples of Indian art between 1970 and 1981. She opened her own museum within a few years in order to create an understanding or appreciation for the "genius," "creativity," and spiritual integrity of Indian culture, and was particularly interested in reaching other Native Americans. See Wade, Haralson and Strickland, pp. 13–15.

99. Personal conversation with Bob Smith, Summer, 1987.

100. John M. Gogol, "American Indian Art: Values and Aesthetics," *American Indian Basketry and Other Native Arts* 4, 4 (December 1984): 6.

 The Collections

The Collecting Experience: General Observations

The story of the evolution of perceptions about Indian art, however fascinating, is an abstract and impersonal tale until it is tied to the lives, stories, and patterns of actual collectors. The "trends" discussed then become personified, immediate, and more easily apprehended. Faceless "collectors" become individuals with distinct motivations and attitudes, and "Indian art" is translated into works of art that create powerful impressions and responses. What emerges is a sense of the affective experience of collecting—the emotional involvement, the intensity, the pleasure, and the vitality.

All of the collections in this exhibition are shaped by the contemporary context discussed above. All have come into being or have grown significantly since the revival of interest in Indian art in the late 1960s, and all are strongly affected by the fact that there is a positive climate for Indian art. All the collections reflect positive, realistic attitudes toward Indians; none were put together for investment purposes or seen as groupings of "curiosities," or souvenirs of "other" types of people. None are based on an assumption that Indians are vanishing; on the contrary, all acknowledge that Indians and the Indian vision are very much alive. None were put together as ethnological repositories, although the cultural/historic context the objects embody are of particular importance in the Indian collections, and to varying degrees, matter to all the collectors. All are interested in and informed about Indian traditions, at least in so far as they are relevant to a particular collecting focus.

The collectors all accept the general premise that the objects are works of art, although the Indian collectors tend to define art more broadly than the non-Indians, considering even artifacts such as tools to be of equal importance in an aesthetic, spiritual sense. Although some of the collectors might not articulate their involvement in these terms, all acknowledge and respond to the underlying spiritual quality of Indian art, a quality or spirit that gives them a special type of richness and beauty.

Together, the seven collections encompass the whole range of objects that are now considered Indian art. Some (Busse, Hootkin) concentrate on contemporary work, produced by artists who are still working and evolving. Some (Van Zelst, Cusick, Little Eagle) are interested in both contemporary artists and unnamed artists of the past. Two (Smith,

Marsik) are most interested in older pieces that speak to them of different times and places, but even the latter collections have some contemporary pieces (Smith is an artist himself, and when a particular type of older piece is unavailable he will sometimes fashion one like it), and both collectors are aware of contemporary artistic trends.

The breadth, complex history and continual evolution of Indian art is also reflected in the fact that every collection includes objects that were originally produced for sale to "outsiders;" these collections are not exclusively made up of what purists of earlier decades insisted was the only "real" Indian art. Trinket baskets, beaded purses, floor rugs and pottery figurines are now as much a part of Indian heritage and history as anything made in the pre-contact period.

Though generalizations are valid, each collection is quite unique. Each has its own focus or "signature;" it is, in the words of a recent book reviewer for *American Indian Art,* a whole that is more than the sum of its parts.[1] Every collector experiences his or her objects differently, and it is the associations generated by the pieces and the meanings they acquire as they are juxtaposed that create this Gestalt. Martha Cusick's model tipi cover (49) is interesting in itself, but when it is seen next to her beaded Sioux vest (50), its figures stand out and make a different kind of sense. When these figures in turn come together with figural sculptures (52, 53, 60, 61) and figural imagery (51, 54, 56, 58), it is possible to understand at least one small part of what this collection is all about. Bob Smith's hanging box (116) can be comprehended in an entirely different way when it is related to his moccasins (106, 113), and hats (114, 115). Some part of the collecting process itself is also implicit in the amassed objects. The excitement and tension of the Marsiks' "hunt" for rare and significant old Southwest artifacts comes through, as do the intense personal feelings elicited by every addition to the Hootkin collection. The diligence and care with which the Van Zelsts and the Busses look for a full range of representative examples is clear and very touching. The multigenerational experiences and tribal associations that collecting has brought the Little Eagle family are also evident when one spends time with their grouped-together pieces.

Five out of these seven collections are, in fact, family collections; the search for and adventure in finding the pieces, the decisions about what to spend money on, the recordkeeping, and certainly

the ongoing day-to-day enjoyment of the pieces are things that are shared by husband and wife, and in many cases, with children as well. The collection becomes more than a group of objects, then, not just because the objects have been selected according to some underlying purpose or because they relate to each other visually or conceptually, but because it is an integral part of the family experience and identity.

Associations with individuals are important to the collectors in other ways as well. For the Hootkins and for Cusick, in particular, there are extremely strong relationships with the artists, and the artworks are charged with the additional meaning of the bond of friendship. There are associations with dealers and with other collectors (Anthony Berlant, a collector of Navajo rugs, captured the inextricableness of these categories when he remarked that every dealer he knows is just a collector who can't stop buying),[2] for deep and long-lasting friendships emerge in many cases among people who share a collecting interest. The Indian collectors in this sample found collector/dealer relationships to be of only minor importance, but as both of their collections have been put before the public, they too have helped facilitate new relationships and friendships.

The collections have strongly affected the direction of some of the collectors' lives, sometimes to the point of changed careers. Cusick, true to Berlant's characterization, found herself becoming a dealer in Indian art in order to "afford" her own collecting and to go deeper into the Indian art world. The Little Eagle family, finding that their collection interested non-Indians who came to the Wisconsin Dells area, used it to draw people to their Indian art shop. Smith, who returned to his Indian community with an extensive collection of Indian objects, soon emerged as director of a tribal museum. His collection did not put him in this position, but his involvement in the collecting process—his search for his Indian heritage, his familiarity with Iroquois objects and traditions—helped him find his way there.

Smith is not the only one who has been brought closer to the Indian people through his collection. The Little Eagles found their Indian identity reinforced by their collecting activities. The non-Indians have either been brought into direct contact with Indians through their passion for collecting, or have steeped themselves in information about Indian art and Indian ways of life. When queried, all the non-Indians indicated a familiarity with current Indian issues and concerns, and each expressed support for the continued Indian struggle for self-determination and self-definition. Some collectors are more anxious than others to share their holdings with others—some see the educational function as one of the prime reasons for collecting—but all are delighted to talk about their pieces and those who made them when they find a sincerely interested audience.

Indian art, as stated in the introduction, is inextricably bound up with cultural associations and assumptions. It has always evoked strong feelings, and it continues to do so today. The way it is perceived may continue to change and evolve, but it will undoubtedly continue to have this impact. It is the power of the Indian vision and Indian spirit that comes through in the pieces that engenders the interest and creates the emotional response. Collections of Indian art are repositories of this vision, concentrated storehouses of its energy. They in turn become repositories of the vision, feelings and associations of the collectors who put them together. They embody something of the interface between the Indian and non-Indian world, and the Indian world of the present and of the past. It is no wonder that collecting Indian art is a consuming, multidimensional experience that becomes a meaningful part of the collectors' lives.

Notes

1. Review of *Pleasing the Spirits* and "American Indian Basketry" in *American Indian Art* 4, 2 (January 1984): 23–25.

2. "Collecting Navajo Weaving: A Panel Discussion," *Four Winds* 2, 2 (Summer-Autumn 1981): 29.

The Van Zelst Collection

The Van Zelsts first became interested in Indian art when they attended a pow-wow about twenty-five years ago. As they travelled with their children, they started looking for out-of-the-way shops and quality work. Because they began collecting before the "boom" of the 1970s, they initially found few young Indians engaged in art production. They felt compelled both to collect older (generally early twentieth-century) pieces to ensure that they would be preserved, and to collect contemporary pieces to encourage the next generation of artists. They bought early pieces from many of the artists who have since become famous. Always able to recognize good work, the Van Zelsts have been in the right place at the right time to make many important purchases. They bought an entire basket collection (one hundred pieces), for example, from Fred Rosenstock, a Colorado bookseller who waited ten years to find a buyer who wanted the lot intact. They were also among the bidders at the pivotal Green Collection auction (see p. 11) in New York in 1971.

The Van Zelst collection has encompassed almost the whole gamut of Indian art, including baskets, pots, silverwork, beadwork, sculpture, and weaving. At one time it even extended into the basketry and feather arts of South America. It is a large and ever-changing collection, for the collectors continually discover new artists whose work they purchase (see 33–36), and continually refine their focus. Often, it is the objects that interest few others that intrigue the Van Zelsts the most.

The collectors have loaned many pieces to temporary museum exhibitions, and over the years they have donated individual pieces or entire sub-collec-

tions to suitable institutions. As they are vitally interested in sharing the pieces with others, the Van Zelsts always determine before making a donation that the work will be properly appreciated, cared for, and shown to the public. Their significant basket collection, a part of which is shown here, was donated to the Elvehjem in 1984.

To the Van Zelsts, these pieces are at once art works, objects to be delighted in, and manifestations of a "magnificent culture" that they hope to bring to public attention. To this end, they involve people of all ages in a variety of ways. Their children, who have been involved with the collection since they were small, have passed their love for the artworks on to their own families. In addition to working with museums, the parents have shared their pieces with public school children and have helped "educate the teachers." They have also lectured on individual artists. They not only talk about the artworks with their friends and acquaintances but often show them to foreign visitors.

The thirty-six pieces exhibited here do not represent the full range of the Van Zelst collection; rather, they represent the range of one of its sub-collections (Indian baskets), and reflect their interest in a young contemporary Indian artist. Every piece stands alone as an aesthetic statement, but taken together, the objects demonstrate the breadth, the incisiveness, the quality, and the ongoing source of pleasure that the collection represents. As they put it, "You fall in love with whatever it is you're interested in," and "you feel good when you know you've had some influence on the way other people see them."

The first five baskets presented here were among those that the collectors acquired from Fred Rosenstock. All represent the kind of high quality southwestern-area baskets that would be likely to find their way to the collection of a dealer of books and memorabilia of the American West.

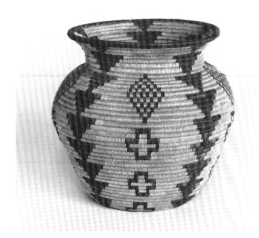

1. Apache basket
c. 1900
Coiled; willow, devil's claw
Undyed fibers (tan, black)
8.5 h.×9.5 dia. in. (21.25×23.75 cm.)
1984.103
Geometric patterns of the type seen here are the oldest design motifs used on Apache baskets. This piece is shaped like a traditional storage basket, but is smaller, and was probably made for sale. The richness of the Van Zelst collection, which includes many baskets from this turn-of-the-century era, can be attributed in part to the avid collectors of that period.

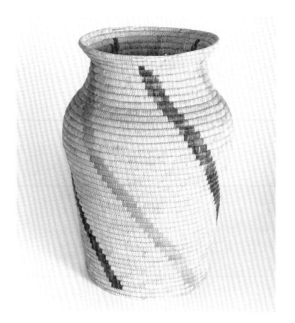

3. Pima wastebasket
Early 20th century
Coiled; willow and devil's claw, cottonwood, bear grass or cattail
Undyed fibers (tan, dark brown)
6.5 h.×9 dia. in. (16.25×22.5 cm.)
1984.102
American Indian baskets were popular accessories in turn-of-the-century non-Indian interiors. Traditional materials and design motifs were adapted to non-traditional forms that accommodated the tastes of non-Indian buyers.

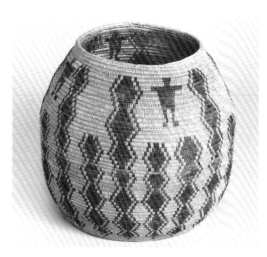

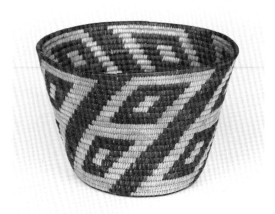

2. Pima (?) basket
Date unknown
Coiled; willow, devil's claw
Undyed fibers (tan, black)
12 h.×12 dia. in. (30.5×30.5 cm.)
1984.143
This basket has been attributed to the Pima, but it has Apache characteristics in its form, design motifs, and construction technique. The design has been described as depicting the legendary figure Suiku standing at the entrance of a trail to his remote home, but that description usually applies to designs with one figure at the entrance of a maze-like configuration.

4. Papago storage basket
1890–1940
Coiled; yucca, devil's claw, bear grass
Undyed fibers (tan, black, brown)
19.74 h.×12.25 dia. in. (49.5×30.5 cm.)
1984.138
This basket, one of the largest in the Van Zelst collection, was probably also made to satisfy the increasing tourist demand after 1890 for baskets of the Southwest.

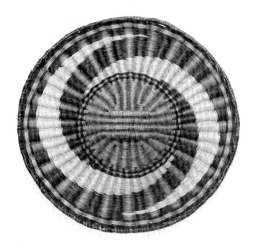

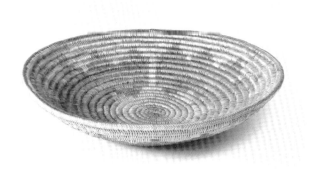

5. Hopi (Oraibi, Third Mesa) plaque
Mid 20th century
Woven; wild currant or sumac, rabbit brush, yucca
Undyed and dyed (red, yellow, black, purple) fibers
12.75 dia. in. (31.8 cm.)
1984.115
The spiraling bands of black and tan on this plaque represent a "whirl-wind" design.

7. Navajo ceremonial wedding basket
20th century
Coiled; sumac
Undyed and dyed (red, black) fibers
3.75 h.×14.4 dia. in. (9.4×36 cm.)
1984.134
This is a special type of basket that before 1930 was made for the Navajo by neighboring Ute and Paiute women. Navajo artists started to make their own at that time. The design, which is almost always the same, has been explained in various ways. The plain center represents the beginning of life or earth, and the innermost black band represents mountains, clouds, or the underworld. This is joined to a red band representing the earth or the color of the sun, which is in turn ringed by another band of mountains, clouds, or the upper world. The outer area may allude to the increase of people on the earth. The coiling terminates opposite the "pathway"—a path interpreted both as a route for the "emergence" of the people and a way to release a spirit at death.

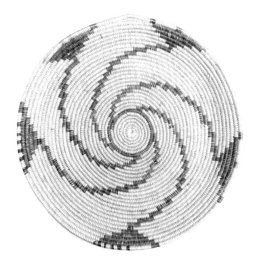

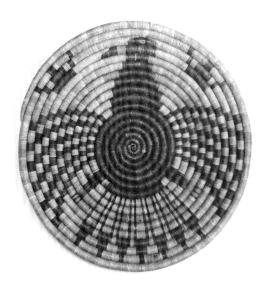

6. "Mission" gambling tray
Late 19th century (?)
Coiled; grasses, sumac (?)
Undyed and dyed (brown) fibers
14 dia. in. (35 cm.)
1984.131
The coiled loop at the edge of this piece indicates it was meant to be hung on a wall. It still has its original tag, which states it is a "Mission Indian" piece from the area between San Bernardino and the Pacific Ocean, and its price is $11.50. "Mission Indian" is a name that designates a group of tribes associated with the Spanish missions in southern California. The collectors successfully bid for the basket at the now-famous 1971 Green collection auction that marked the beginning of a new interest in American Indian art in art-world circles, and a steady increase in prices. It is a rare work that reflects the breadth of the Van Zelst collection.

8. Hopi (Second Mesa) sacred meal tray
1890-1930
Coiled; yucca, grass
Undyed and dyed (brown) fibers
14 dia. in. (35 cm.)
1984.117
Figurative designs were abstracted and arranged to fit basket forms, as is evident in this eagle motif.

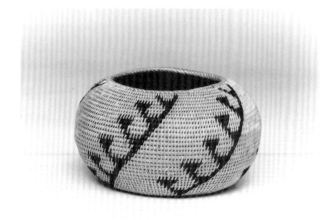

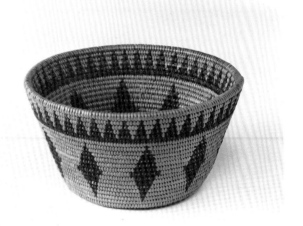

9. Washoe basket
Late 19th-early 20th century
Coiled; willow, bracken fern
Undyed fibers (tan, black)
3.25 h.×6 dia. in. (8.1×15 cm.)
1984.151
Baskets made by certain groups from the Southwest and California were avidly sought after by turn-of-the-century collectors. One Washoe basketmaker, Louisa Keyser (Dat-so-la-lee, 1835-1925), was so renowned that Washoe baskets were particularly valued. The identity of all but the star basketmakers, however, was not a general concern of period collectors, and remains unknown today.

11. Mary Snyder (Chemehuevi), basket
1880-1930
Coiled; willow, devil's claw
Undyed fibers (tan, black)
2.5 h.×5 dia. in. (6.25×12.5 cm.)
1984.175
The Chemehuevi were among the finest Indian basketmakers, and this piece was made by one of the best of the Chemehuevi weavers. It was originally purchased by Birdie Brown, who ran a trading post with her husband in Parker, Arizona, near the Chemehuevi reservation. Brown bought over 1400 baskets from her neighbors, and had the largest Chemehuevi collection in the world. The Van Zelsts acquired this piece from the Heye Museum (Museum of the American Indian) after the Brown collection was sold in 1970.

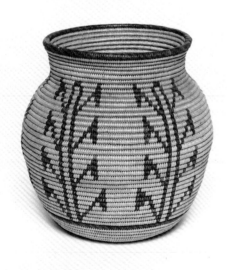

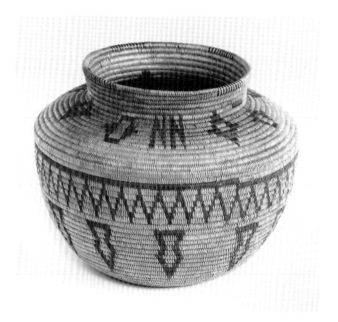

10. Chemehuevi basket
Late 19th-early 20th century
Coiled; willow, devil's claw
Undyed fibers (tan, brown)
6.75 h.×6.75 dia. in. (16.8×16.8 cm.)
1984.104

12. Chemehuevi (Panamint?) basket
c. 1900
Coiled; willow, devil's claw
Undyed fibers (tan, black)
4.5 h.×5.5 dia. in. (11.25×13.75 cm.)
1984.174
Although it is as finely crafted as the Chemehuevi baskets, this piece has design details that are more typical of the Panamint. It also came to the collectors from the Green collection auction (see 6).

Perhaps the best known and most highly valued of all American Indian baskets are those made by the Pomo. Their technical virtuosity and skillful integration of exquisite feathers, shells and other materials have almost universal appeal. "Fancy," highly-deco- rated baskets of the type represented here were made both for other Indians and for sale. Such baskets were in effect collected by Indians as well as by members of the mainstream culture.

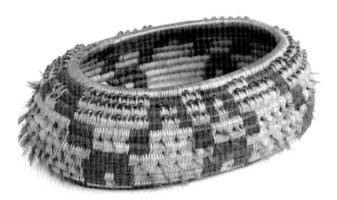

13. Pomo treasure basket
c. 1900
Coiled; willow, sedge and bulrush roots, woodpecker feathers, glass beads
Undyed fibers (tan, black) and feathers (red)
1.25 h.×4.5 max. dia. in. (3.1×11.25 cm.)
1984.106
Small Pomo baskets like this were sold at the turn-of-the-century for under ten dollars.

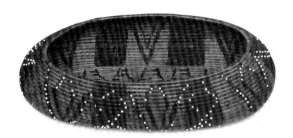

15. Pomo gift basket
Late 19th-early 20th century
Coiled; willow, sedge and bulrush roots, woodpecker feathers, glass beads
Undyed fibers (tan, black) and feathers (red); beads (white)
2.75 h.×12.75 max. dia. in. (6.8×31.8 cm.)
1984.145
Fine baskets like this were given as gifts among the Pomo people. They were given at marriages or other special occasions, or as a sign of admi- ration and appreciation. Many were passed down from generation to generation of Pomo families.

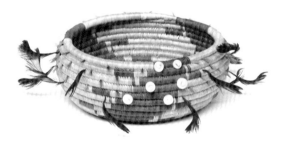

14. Pomo basket
c. 1900
Coiled; willow, sedge and bulrush roots, clam shell and glass beads, woodpecker and quail feathers
Undyed fibers (tan, black), feathers (red, black), and beads (white)
1.5 h.×5.5 dia. in. (3.8×14 cm.)
1984.107
Red woodpecker feathers and black quail topknots are inlaid in the light portions of the design. The L-shaped designs at the edges of the dark areas also form a quail motif.

16. Pomo jewel basket with wampum bead handle
Mid 19th-early 20th century
Coiled; willow, sedge and bulrush roots, clamshell disc beads, string
Undyed and dyed (black) fibers; beads (white)
1.75 h.×5.5 max. dia. in. (4.4×14 cm.)
1984.146
Wampum or clamshell beads were at one time a medium of exchange, and when they were used for ornamentation, as they were here, they implied wealth and prestige. This piece was purchased at the Heard Museum.

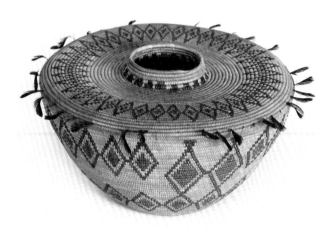

17. Yokuts basket
c. 1900
Coiled; willow, redbud, sedge, quail feathers
Undyed fibers (tan, black, brown) and feathers (black)
6 h.×12.5 dia. in. (15×31.25 cm.)
1984.111
Because they are so well made and their designs are so similar, Yokuts baskets are often mistakenly identified as Pomo. Actually, many California tribes had highly developed basketmaking traditions. The sharply curved shoulder of this piece indicates a Yokuts origin, a designation reinforced by the "diamondback rattlesnake" bands and the quail topknots.

Miniature baskets are an integral part of Indian basketmaking traditions throughout the North American continent. They are not intended to be used, but to display the artist's command of her medium and to provide aesthetic pleasure. The Van Zelst collection includes miniatures from many parts of the country—an inclusion that reflects an understanding of Indian baskets and a commitment to illustrating the breadth and variety of American Indian art.

18. Pomo miniature feather-covered basket
Late 19th-early 20th century
Coiled; sedge root, willow, mallard and meadowlark feathers
Undyed fibers and feathers (yellow, blue-black)
.38 h.×1 dia. in. (1×2.5 cm.)
1984.156
Pomo miniature baskets, like those made by other Indian artists, showcase technical virtuosity. The alternating yellow and blue-black feathers were inlaid into the sides of this tiny basket as it was being coiled.

19. Mohawk (Iroquois) thimble basket
20th century
Woven; ash splint, sweet grass
Undyed fibers
1.5 h.×1 dia. in. (3.8×2.5 cm.)
1984.13

20. Cherokee miniature basket with handles
1960-1980
Woven; white oak splint, honeysuckle
Undyed and dyed (black) fibers
2 h.×1.5 dia. in. (5.1×3.8 cm.)
1984.157

21. Pearl White Eagle (Winnebago), miniature basket
c. 1970
Woven; black ash splint
Undyed and dyed (red, purple) fibers
1.5 h.×1.75 dia. in. (3.8×4.4 cm.)
1984.152

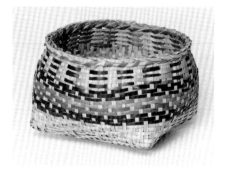

22. Chitimacha basket
Date unknown
Woven; river cane
Undyed and dyed (black, red-orange) fibers
2 h.×3.75 dia. in. (5.1×9.5 cm.)
1984.173

These baskets were created with the same materials and techniques that are used to make full-size baskets, but the wood and vine fibers were split to the tiny size required by the small scale of the finished pieces. The basket made by Pearl White Eagle (21) was purchased in the Wisconsin Dells area, where Winnebago baskets have been sold to collectors for more than one hundred years.

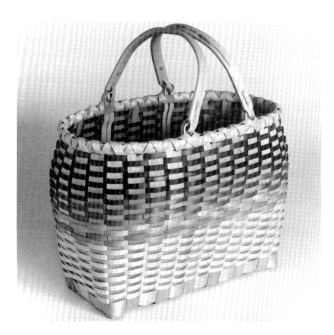

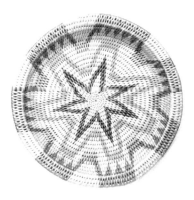

25. Athapascan tray
20th century
Coiled; willow
undyed and dyed (green, purple, orange) fibers
13.25 dia. in. (33.1 cm.)
1984.162
This unusual tray from the Alaskan interior indicates the stylistic as well as the geographic range of the Van Zelst collection.

23. Winnebago basket with handles
1970–1980
Woven; black ash splint
Undyed and dyed (polychrome/rainbow progression) fibers
12 h.×16.25 w.×9.5 d. in. (30×40.6×23.75 cm.)
1984.153
The Van Zelsts want their collection to include contemporary as well as historic Indian art forms, and look for high-quality representative examples wherever they go. This "rainbow" basket was also purchased in the Dells area (see also 21), and represents one of the most recent additions to the collectors' group of baskets.

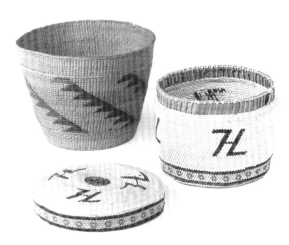

26. Tlingit commercial-type berry basket
1890–1920
Twined and woven; spruce root, maidenhair fern, bear grass
Undyed (tan, black) and dyed (orange) fibers
3 h.×4 dia. in. (7.5×10 cm.)
1984.149
This piece is shaped like a traditional Tlingit "berry basket," but its small size indicates it was made for sale rather than for gathering fruit. The base of commerical baskets of this type was made with a combination of weaving and twining; the base of a true berry basket was completely twined. Small-scale versions of utilitarian baskets (see also 1) were often made for sale at the turn-of-the-century, and despite their reduced size and changed stylistic details were collected as "traditional" Indian forms.

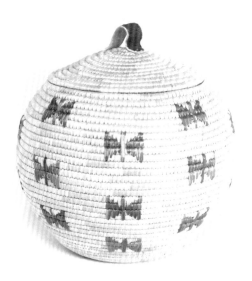

24. M. Chagluak (Eskimo), lidded basket
c. 1970
Coiled; rye grass, sealskin
Undyed and dyed (purple, red) fibers
6.25 h.×6.5 dia. in. (15.9×16.5 cm.)
1984.160
The vertical rows of red and purple butterflies are stitched with brightly dyed rye grass. Baskets of this type were only introduced into this area of Alaska after the turn of the twentieth century, but Eskimo artists quickly developed the technique and evolved a strong and unique basket repertoire.

27. Makah trinket basket
Late 19th-early 20th century
Twined and plaited; bear grass, sedge, cedar bark
Undyed and dyed (purple, red, gold) fibers
2.75 h.×3.87 dia. in. (7×8.9 cm.)
1984.124
"Trinket" baskets were also made expressly for sale, but were based on older construction methods. The analine dyes that colored the bear grass on these pieces have faded with age. The parts of the baskets that have not been exposed to light show the dyes in their original intensity.

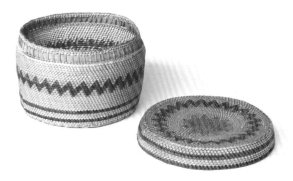

28. Makah trinket basket
Late 19th-early 20th century
Twined and plaited; bear grass, sedge, cedar bark
Undyed and dyed (purple, orange, red, yellow) fibers
2.75 h.×3.87 dia. in. (7×9.8 cm.)
1984.123

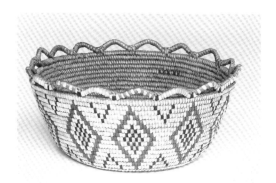

29. Yakima basket
Late 19th-early 20th century
Coiled with ribbon bark imbrication; cedar root and bark, horse-tail root
Undyed (tan, brown, black) and dyed (yellow) fibers
4 h.×9 dia. in. (10×22.5 cm.)
1984.178

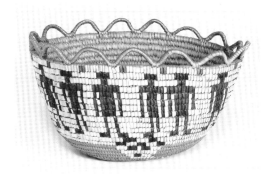

30. Yakima basket
Late 19th-early 20th century
Coiled with ribbon bark imbrication; cedar root and bark, bear grass, horsetail root
Undyed fibers (tan, black)
5 h.×7 dia.× l. in. (12.5×17.5×22.9 cm.)
1984.179
Included among the human figures that adorn this basket are two that are thinner than the others, and have only one foot. The deliberate placement of these unusual figures indicates their distinct appearance is intentional, but the meaning of the variation is unknown.

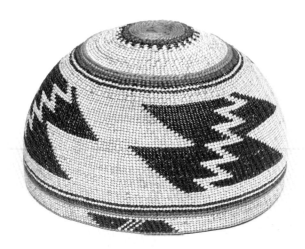

31. Karok-type woman's hat
Date unknown
Twined with full twist overlay; hazelnut shoots, maidenhair fern, squaw or bear grass, pine root
Undyed fibers (tan, brown, near-black)
3.75 h.×6.5 dia. in. (9.3×16.25 cm.)
1984.163
The dominant pattern on this hat represents a "flint" design, a reference to the obsidian traditionally used for making ceremonial knives and tools.

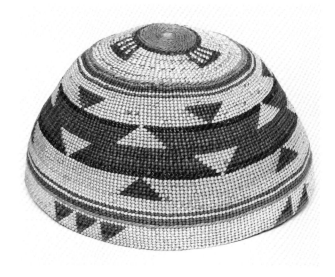

32. Karok-type hat
Date unknown
Twined with full twist overlay; hazelnut shoots, maidenhair fern, bear grass
Undyed (tan, brown, black) and dyed (brown) fibers
3.88 h.×7.37 dia. in. (9.8×18.4 cm.)
1984.164
The counterchange design used here is called "Waxpoo," and is characteristic of hats of this type. It refers to "the middle," but its meaning is uncertain.

Norbert Peshlakai is a young, innovative artist who for about ten years has been adapting silverwork techniques usually associated with jewelry to small, precise sculptural forms. His pots, in particular, evoke Indian basket and pottery forms, but are thoroughly unique.

The Van Zelsts came upon Peshlakai's work very early in its development and responded to it immediately. They have continually encouraged the artist, and have examples of most of the different kinds of pieces (the latest is a set of cutlery) he has produced.

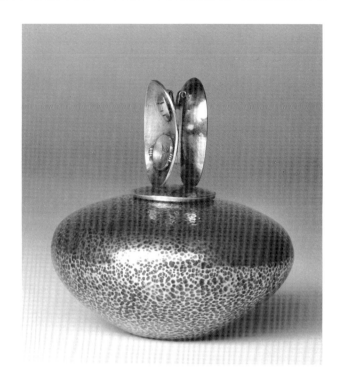

33. Norbert Peshlakai (Navajo), "Woman with Butterfly Basket"
1985
Raised and fabricated; silver
3.5 h.×3.25 dia. in. (15.2×10.2 cm.)
In a letter to the collectors, Peshlakai explained that as a child herding sheep he used to watch butterflies fly from one blossom to another. He related a Navajo cautionary tale about a man who caught a butterfly that came to life as a young girl but quickly aged into an old woman. The elders told the story so herders would not be distracted by the beautiful butterflies but would keep their eyes on the animals.

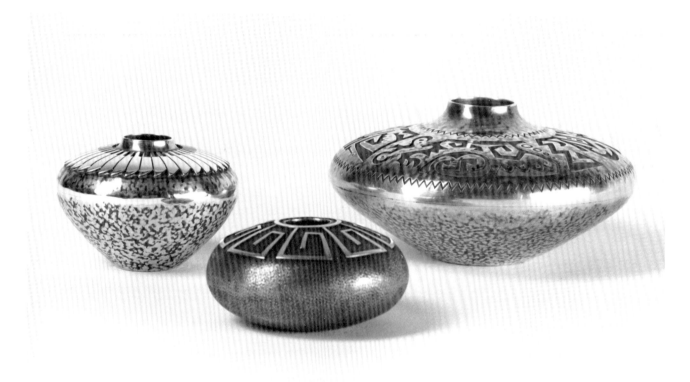

34. Norbert Peshlakai (Navajo), silver pot
1985
Raised and fabricated; silver
1.6 h.×2.25 dia. in. (2.8×5.5 cm.)

35. Norbert Peshlakai (Navajo), silver pot
1987
Raised and fabricated; silver
1.5 h.×2.25 dia. in. (3.75×5.5 cm.)

36. Norbert Peshlakai (Navajo), silver pot
1979
Raised and fabricated; silver
1.75 h.×4 dia. in. (4.7×10.2 cm.)
This was one of Peshlakai's earliest pieces, and was worked with hand-made tools fashioned from old nails and other scrap metal. The silver is hammered both inside and out. The pot won first prize at the 1979 Indian Market in Santa Fe, and was later the only piece by a living Indian artist included in a special exhibition at the Art Institute of Chicago.

 The Marsik Collection

George and Grace Marsik became interested in American Indian art in about 1965 when they saw a Navajo rug in an antique shop. Once they bought the piece, they started learning more about it. Soon they were "upgrading," and specializing in nineteenth-century weavings; later, they added historic pottery to the collection. At one time they had about 300 pieces, but the Marsiks kept getting more selective, and eventually they honed their collection down to one-tenth that size. Their approach is that "less is more;" a few outstanding pieces are worth a great deal more than many mediocre ones. The entire collection, with the exception of a few works by Helen Cordero, who is a friend, now consists of rare, older Navajo blankets and pueblo pottery.

Mr. Marsik is keenly involved in the collecting process. On any given day he spends time reading, making phone calls or otherwise following through on the study of Indian art, and he makes it a point to get to every museum exhibition he can. "It's a matter of being so interested and wanting to see all possible examples," he explains, "that you travel, you learn about them, read about them, talk to other peopleIt takes all your spare time."

Because there are few extant examples of the type of work the Marsiks like, collecting becomes a kind of hunt or chase, and engenders a great deal of excitement. They are always tracking down the few pieces that might become available. In one case they followed a set of pots for over ten years, and finally found it in an unexpected context. In another, they chased across the country after a particular rug (47). They know all the traders and dealers—"we have to know them; each one might be the one that comes up with something"—and they know all the other collectors who are looking for the same kinds of pieces. There is a good-natured competition among these people, as well as a camaraderie, and their interaction becomes integral to the collecting experience. The race for the prize pieces requires vigilance, persistence, and devotion, and it is part of what makes collecting stimulating and pleasurable for the Marsiks.

The collection is also pleasurable because it is aesthetically so satisfying. Art is an important part of the Marsiks' life. They love having the pieces around them, and being able simply to sit down and look at them. They appreciate everything that went into making them what they are. The Marsiks also collect Bohemian glass, Tiffany lamps, and paintings, but their Indian art is most meaningful to

them, in part because it is very special (so few pieces exist), and in part because it is extremely rich in historic meaning.

Although some figural pottery was made in all Southwestern pueblos in the past, such works were most common at Cochiti. Figures had been made for both ritual purposes (see 60 in the Cusick collection) and for commercial sale. Humorous sale figures were enormously popular around the turn of the century (see 61 in the Cusick collection). The tradition died out after the heyday of collecting Indian objects at the turn of the century.

Helen Cordero began to experiment at Cochiti with what she calls her "little people" in the 1950s, and in 1964 fashioned her first Storyteller (see 103 in the Hootkin collection), a figure inspired by the figural traditions of her ancestors, but wholly her own invention. Specifically, it was based on her memories of her own storyteller-grandfather, Santiago Quintana. Cordero's figures immediately struck a responsive chord. Her work was soon featured in such places as the Smithsonian Museum and the cover of *Sunset* magazine, and she was inundated with orders. In 1973, all the figures in her one-woman show were sold before the gallery doors even opened.

By the late 1970s other potters had begun to make Storytellers and similar figures of their own. Storyteller shows have been held annually, in fact, since 1979. In 1983, according to an estimate by scholar Barbara Babcock, there were at least forty-five people at Cochiti making figural sculpture, and about 160 potters in other pueblos, following the Cordero/Cochiti ideas but interpreting them in their indigenous clays and techniques. This contemporary activity has also created new interest in the older Cochiti forms, and has raised their market value considerably.

The Navajo made blankets in the nineteenth century for functional use as outer garments, and they were so admired by Indians of other tribes that they became a popular trade item. They are not worn by "chiefs;" the name Chief Blanket originated with white traders or merchants, who recognized them as high-status commodities.

The blankets are now referred to with a "First," "Second," or "Third Phase" designation, based on their age and design. Color and motifs became increasingly complex over the course of the nineteenth century.

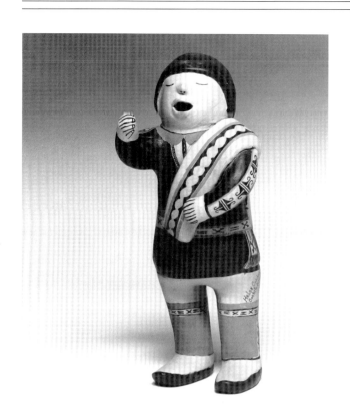

37. Helen Cordero (Cochiti), "Night Crier"
1978–1979
Handbuilt and slip-painted; clay
White, brown, black
15 h.×6.5 w.×6 d. in. (38.1×16.5×15.3 cm.)
Cordero branched out to other types of figures in the 1970s. The Night Crier is another community character, a kind of town crier that stands at the top of the pueblo and makes announcements. The Marsiks do not focus on contemporary artworks, but make an exception for the Cordero pieces because they feel they are so remarkable. They estimate that there are only about five Night Criers altogether, and they bought this one from the artist at her home.

38. Helen Cordero (Cochiti), creche
1981
Handbuilt and slip-painted; assembled; clay, wood, straw, wire
White, gray, red-brown, black
12 h.×28 w.×35 d. in. (30.5×71×89 cm.)
The collectors waited eleven years for this piece. When they first requested a creche from the artist, they thought she made them often, but later discovered they were very rare. Eleven years after their initial request, Cordero called them to announce it was ready. The Marsiks promptly flew to Cordero's house to pick up the piece. They repeatedly stress how fortunate they are to have it, and the creche is one of their favorite pieces. (See 102–104 in the Hootkin collection.)

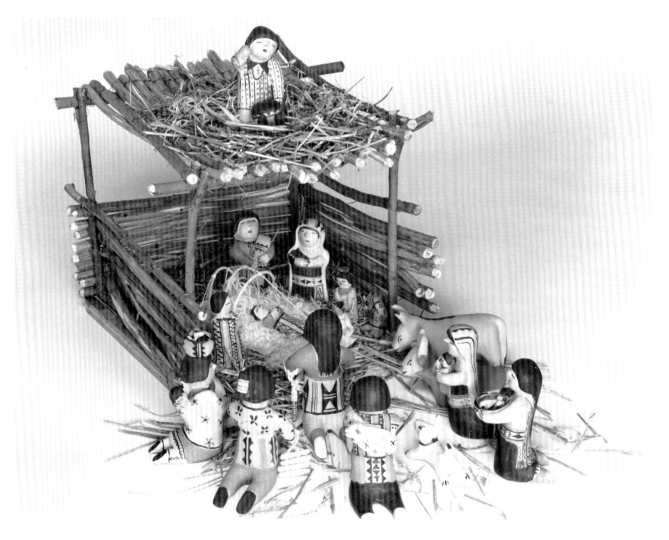

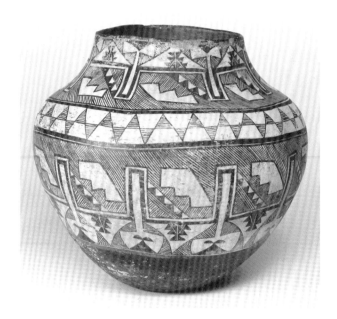

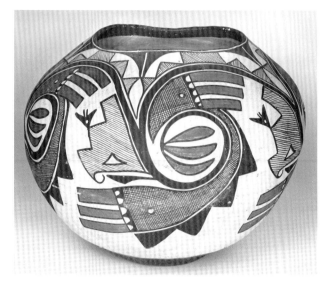

41. Zuni water bowl
c. 1885
Handbuilt and slip-painted; clay
Black, white, red-brown
12.5 h.×15.5 dia. in. (31.7×39.4 cm.)
Part of the late nineteenth-century pueblo pottery revival was based on motifs and forms found on extant remains of prehistoric pots from the area. The curving bird forms and fine line hatching were adapted from ancient Tularosa designs.

39. Acoma pot
1885–1890
Handbuilt and slip-painted; clay
White, black, brown
12.5 h.×13.5 dia. in. (31.7×34.3 cm.)
The geometric "fine line" hatched designs that cover this pot are characteristic of one style of Acoma pottery that was valued by collectors at the end of the nineteenth century.

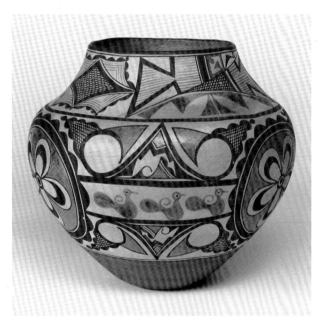

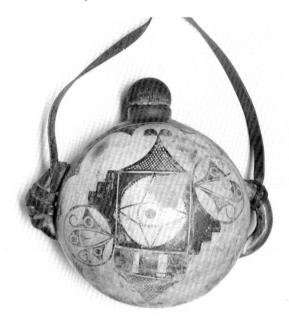

40. Acoma pot
1895–1900
Handbuilt and slip-painted; clay
White, black, red-orange
12 h.×13 dia. in. (30.5×33 cm.)
Although this pot was made at Acoma, it shows considerable Zuni influence in its four decorative bands, its large rosettes, and its row of birds.

42. Zia canteen
c. 1890
Handbuilt and slip-painted; clay, leather, cork
White, black, red-brown
10.25 h.×11 w.×6.5 d. in. (26×28×16.5 cm.)
Because the Zia pueblo is situated on a mesa capped with volcanic lava and has little fertile land, the Zia people have always had to rely on trade for agricultural products. Pottery was a main trade item, and was of consistently high quality. This piece was probably not made for non-Indian collectors, but for functional use. The cork and leather straps are part of its original trappings.

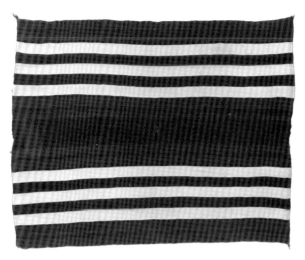

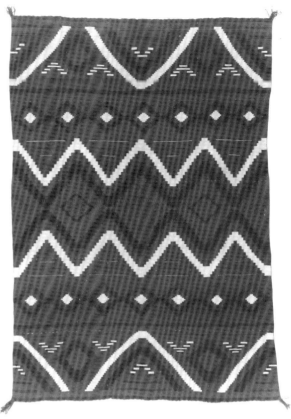

43. Navajo (First Phase) Chief Blanket
1800-1840
Woven; wool
White, indigo, brown
55.25 l.×71 w. in. (140.4×180.8 cm.)
It is unusual for a blanket of this vintage to have survived intact, and
the piece is the oldest in the Marsik collection. Designs of this type
were favored by the Ute tribe, and this piece was probably used at one
time by them. The collectors value it for its rarity and its connections
with two Indian cultures.

44. Navajo (Third Phase) Chief Blanket
1865-1870
Woven; wool
Red, white, indigo, brown, green
53.5 l.×73 w. in. (136×185 cm.)
Third Phase pieces of this type represent one of the last expressions of
the wearing-blanket tradition, and begin to show signs of more complex
patterning. Interestingly, this blanket was purchased from an Oriental
rug dealer. (Color plate, p. 33)

45. Navajo serape
1850-1860
Woven; wool
Red, indigo, white, green
52 l.×75 w. in. (132×190 cm.)
The serape is a Navajo garment form based on Spanish (Mexican) influ-
ence. This is an excellent example of its type, and is one of the collec-
tors' favorite pieces. They are especially proud to have both a serape
and a First Phase Chief's blanket—few collectors can claim such a
distinction.

The term "Germantown" comes from the word
used to describe the wool that the textiles are made
of. Germantown was a kind of generic name for a
three- or four-ply factory-produced yarn, brightly
colored with analine dyes. Because the yarns were
soft, fine and pliable and the color range was wider
than it had been before, intricate and complex new
designs were possible. There were innovative exper-
iments with pictorial images and "eyedazzling"
effects. Yarns of this type were only used in the
turn-of-the-century period.

46. Navajo Germantown blanket
c. 1885
Woven; wool
Red(s), white, green(s), yellow, orange, black, blue(s)
68 l.×69.25 w. in. (172×175.5 cm.)
Fine Germantown yarns made this kind of small-scale pattern
possible. It is an unusual design format.

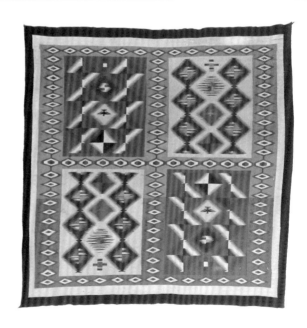

47. Navajo pictorial blanket
1880-1885
Woven; wool
Red, white, black, green
50.5 l.×31 w. in. (128.3×78.7 cm.)
The collectors went to great lengths to get this piece, which is historically important. It is one of the earliest pictorial Navajo textiles, and includes images of the trains which had recently come to the reservation area. Marsik was told there had been a "rug with trains on it" at a show that he had missed. Through a series of telephone calls, he tracked down the exhibitors and made an all-night, marathon drive to Pennsylvania to catch them before they left their hotel. When he found the blanket he was overwhelmed: he recognized it was made by the same artist who created a renowned piece in the George Wharton James collection. The Marsiks lovingly call it their "choo-choo train" blanket. (Color plate, p. 34)

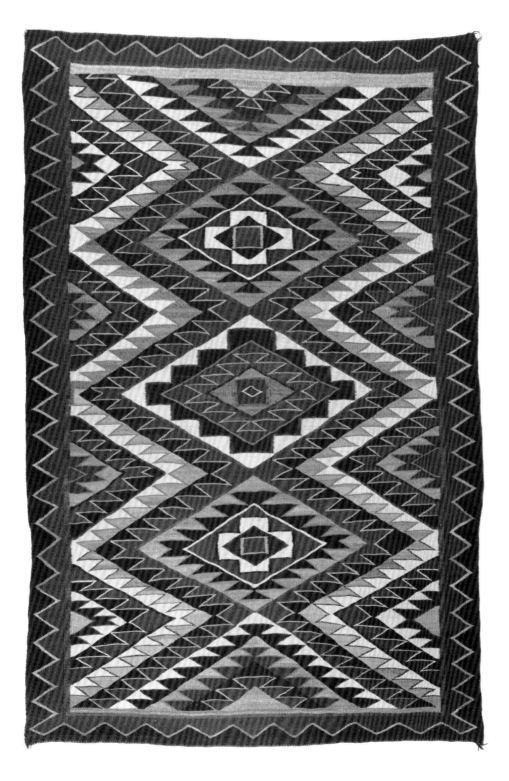

48. Navajo (Red Mesa) Eye Dazzler rug
1915-1920
Woven; wool
Red, orange, yellow, white, black, gray, brown, green
86 l.×55 w. in. (218×139.7 cm.)

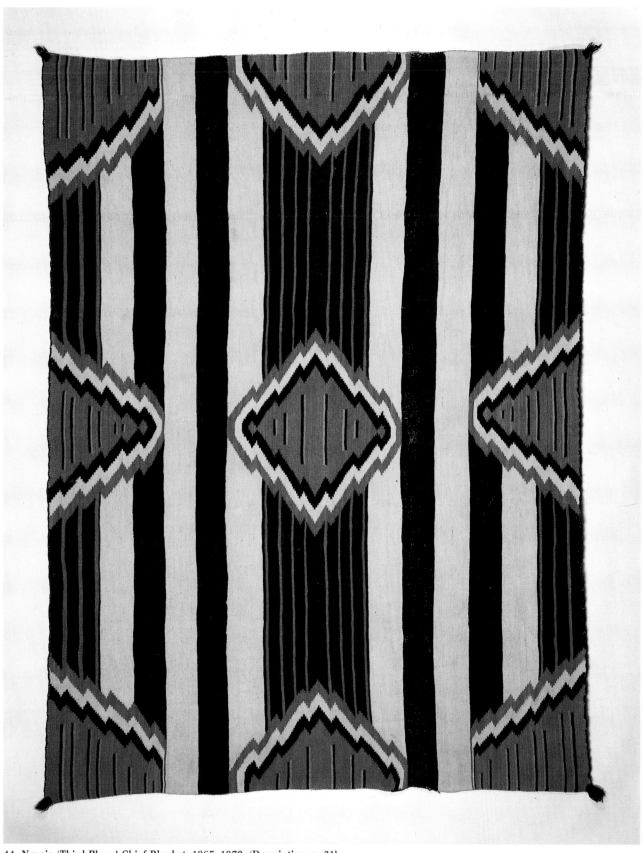

44. Navajo (Third Phase) Chief Blanket, 1865–1870 (Description, p. 31)

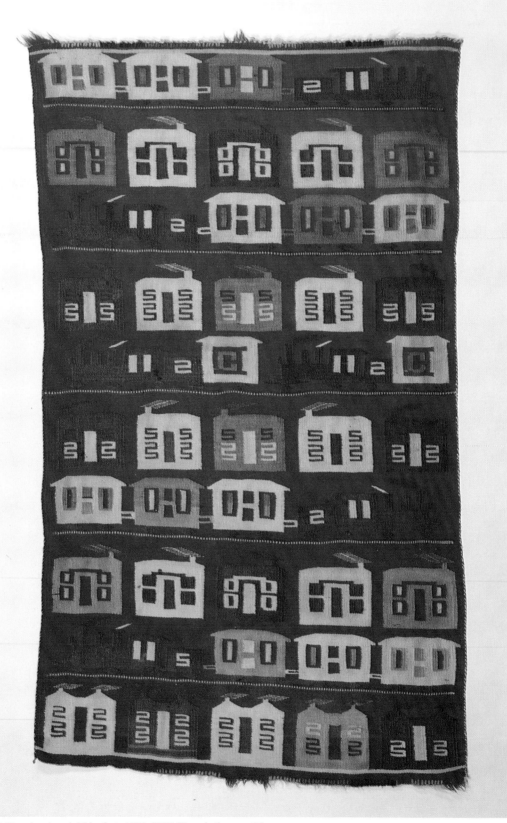

47. Navajo pictorial blanket, 1880–1885 (Description, p. 32)

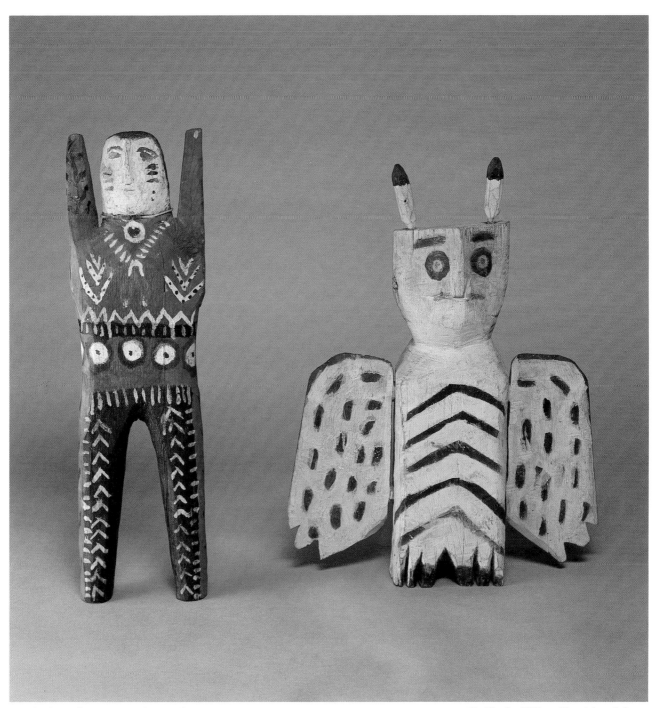

53. Charles Willeto (Navajo), human figure
1950–1970 (Description, p. 43)

52. Charles Willeto (Navajo), owl figure
1950–1970 (Description p. 43)

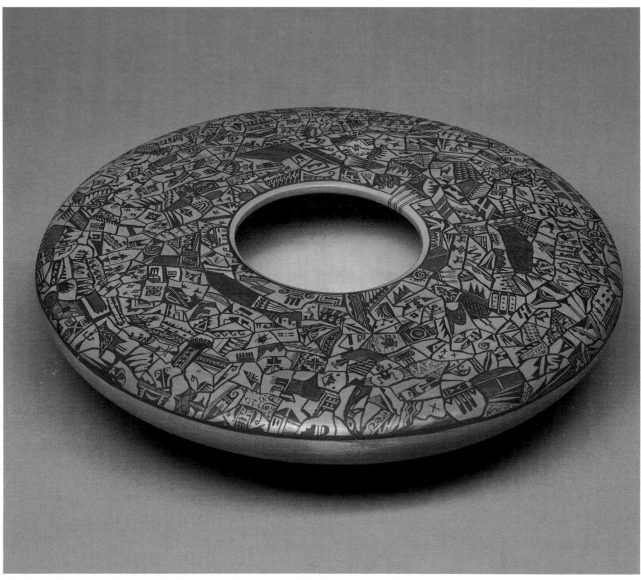

58. Dextra Quotskuyva Nampeyo (Hopi), sherd design seed jar, 1980 (Description p. 45)

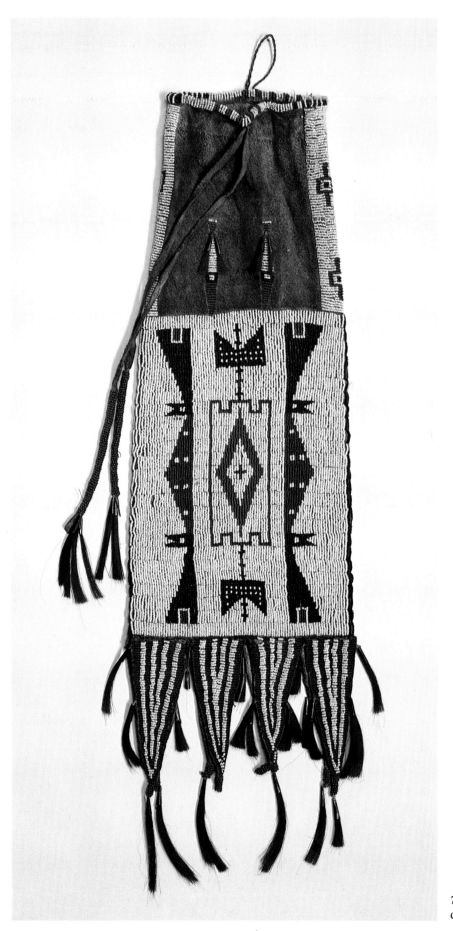

71. Sioux pipe bag, Late 19th century (Description, p. 49)

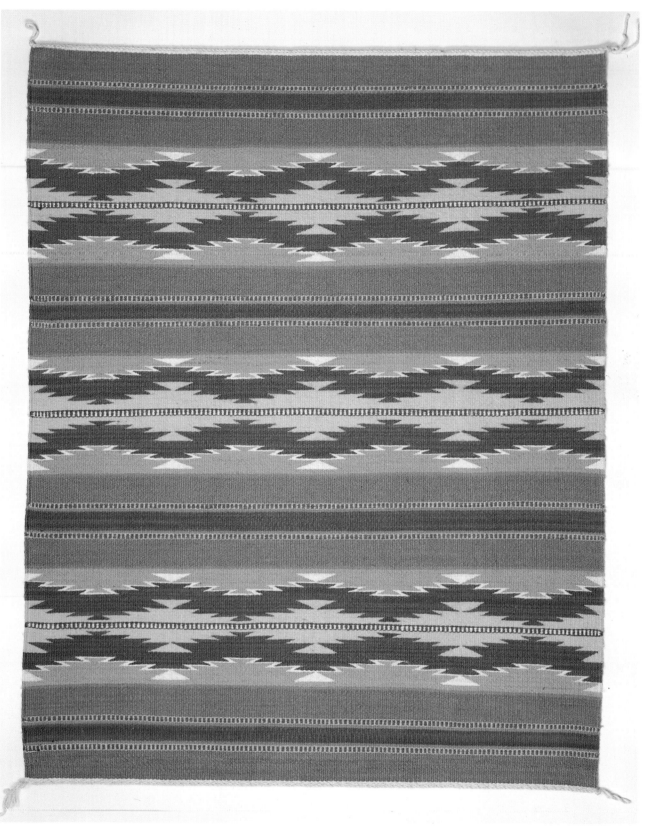

89. Rena Berchman (Navajo), Wide Ruins rug, 1986 (Description, p.57)

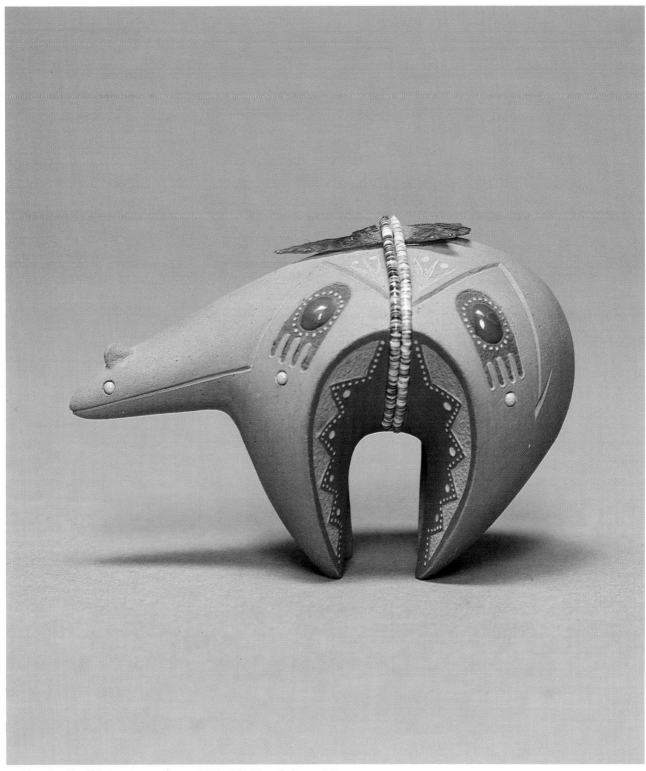

99. Tony Da (San Ildefonso), bear figure, 1970–1980 (Description, p.61)

114. Iroquois brimmed hat, 1875–1880 (Description, p. 67)

The Cusick Collection

Martha Lanman Cusick was first attracted to Indian art in the 1950s when she saw a bowl that her mother-in-law had purchased a decade before. She found it very beautiful, and although she didn't start buying any pieces of her own for many years, she carried its image in her mind. In 1970, after she spent some time travelling in the Southwest, she bought her first piece—a pot by the already-famous Maria Martinez. She purchased a few other pots, but it wasn't until 1974, when her children were nearly grown, that her involvement really took off. She found she had a discriminating eye and a talent for starting friendships with practicing artists, and realized that she could buy some pieces on a wholesale basis and resell them to others. She no longer limited her selections to Southwestern pottery, but branched out into Indian art of all kinds. In 1976, she rented space in a Chicago gallery and became a "dealer" in a formal sense.* At the same time—and largely because her professional involvement gave her the contacts and the knowledge to find the pieces that were most special to her—she built her own very meaningful personal collection.

Cusick is drawn to three-dimensional, textural pieces, anthropomorphic images, to humor, and to what she calls American Indian folk art, that is, pieces that have a "childlike naivete" which she finds touching. She likes "good" things—the best examples of prehistoric, historic, or contemporary art—and she responds to a directness or an honesty in objects of all kinds. Her criteria are definitely aesthetic, but she feels that what makes the pieces so successful is that they embody the lifestyle of the people that made them. She relates to them as part of the Indian people, and she loves them as living, personal things—as friends. She becomes enormously excited when she finds something she likes, sometimes even "blurting out" how wonderful it is. The experience of finding the things is also part of the personalization and the emotionality. "I can't imagine looking at those pieces that are really important to me and not thinking about when I got them. Each piece is a story."

Cusick approaches the subject of Indian art with a passionate interest and curiosity, and goes to great lengths to garner information. She reads voraciously and makes a point of seeing pieces wherever she can. She has become very close to many of the practicing artists in the Southwest and champions the work of those she believes in. Cusick has even brought artists to the Midwest to introduce them to potential buyers. Having curated several exhibitions (see p. 45), she is bursting with plans for several others. She has also served as a pottery judge at contemporary Indian art shows and led travel groups that introduce people to Southwestern art. Cusick's energy and enthusiasm are so infectious that she is able to pass on to others something of the integrity and beauty—the soul—of the art that much of her life revolves around.

*The gallery has since closed.

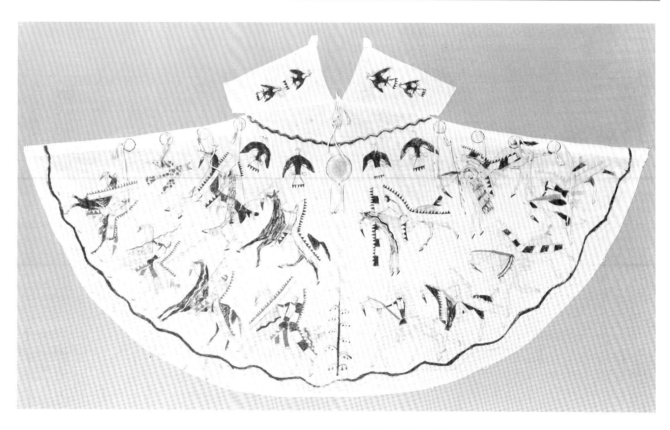

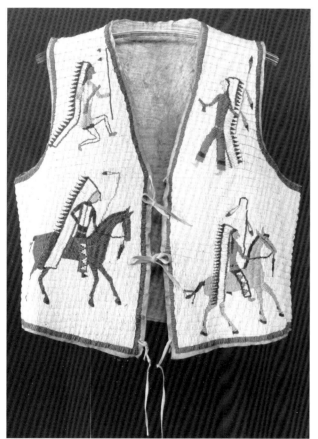

49. Lakota Sioux tipi model

c. 1880–1890

Sewn and painted; muslin, porcupine quills, rawhide

Yellow and red water color, black ink on unbleached muslin

27.75 h.×50 w. in. (69×125 cm.)

This miniature version of a full-scale tipi cover might have been made for a child, or it may have been commissioned by a soldier who was stationed near the reservation. It found its way at one time into the Museum of the American Indian Shop.

50. Sioux vest

1885–1895

Lazy stitch applique beadwork; leather, glass beads, rawhide

White, blue, green, pink, brown, black, red, silver and yellow beads

20 h.×19 w. in. (50.8×47.5 cm.)

The magnificent beaded design on this vest illustrates Sioux warriors counting coup on Crow adversaries. The warrior it was made for traded it for a European-style shirt in Cheyenne, Wyoming in 1900. Cusick acquired it from the third generation of the white family that made the trade.

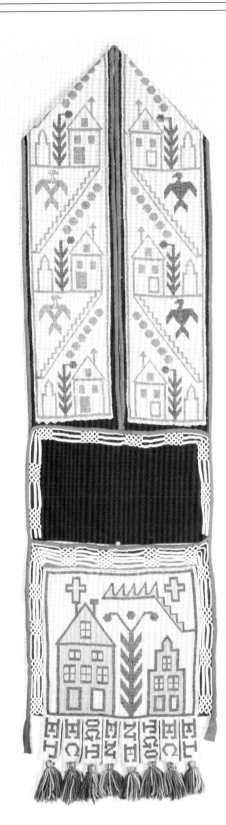

rated pouch area hung down at one side (see also 65, and 66). They were made to be decorative rather than functional; many of the later examples do not even have a usable pouch. They were treasured and delighted in, and because they were often given as gifts, they are sometimes known as "friendship bags." The lettering on this relatively early example does not have any apparent meaning; it was probably used simply as a decorative element (see also 57). The buildings and other images add a lively "folk" quality to the piece that the collector enjoys.

52. Charles Willeto (Navajo), owl figure
1950–1970
Carved and painted; wood
Pale blue, black
19.75 h.×14.25 w.×3.25 d. in. (49.4×35.6×8.1 cm.)
(Color plate, p. 35)

53. Charles Willeto (Navajo), human figure
1950–1970
Carved and painted; wood
Ochre, white, black, blue
21.25 h.×6.5 w. in. (53.1×16.5 cm.)
Willeto's (pronounced Wileeto) figural carvings may have been inspired by simple figures traditionally used in Navajo healing ceremonies. They are unique, however, and represent an individual interpretation and vision. There are still many unknowns about this work: the artist was even referred to by a different name—Alfred Walleto—in a 1979 exhibition at the Wheelwright Museum. Cusick is strongly attracted to these figures (she has several others in her collection), and she is actively researching them at present, with the hope of having Willeto's work recognized and appreciated by the art community.
(Color plate, p. 35)

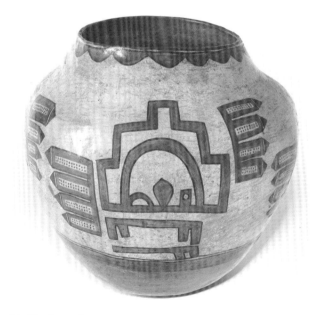

51. Chippewa bandolier bag
c. 1880
Woven and spot-stitch applique beadwork; wool, glass beads
Yellow, pink, orange, green, blue and white beads; black, red and blue wool
42 h.×10.5 w. in. (105×26.25 cm.)
Great Lakes Indians adapted the bandolier bag from the ammunition pouches that European soldiers carried in the eighteenth century. They wore the bags over the shoulder and across the chest, so that the deco-

54. Zia storage jar
1890–1910
Handbuilt and slip-painted; clay
Tan, red-brown, black
16 h.×18 dia. in. (40.6×45 cm.)
Zia pottery of this sort was often made for sale, but its designs are very similar to those found on Santa Anna pots made for local use. The semicircular motifs, in particular, had been typical of both pueblos for more than one hundred years. The stepped motif represents rain, clouds, and the idea of emergence. Feather motifs are also present.

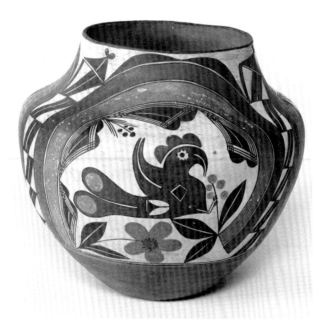

other pueblos. The motifs on the outside are symbolically related to water, a focus of ceremonial ritual because of its scarcity. The motifs on the inside surface relate to heaven and the underworld, and to the four directions. The central image represents the sun, but the face has eroded through usage. The four large animals have "lifelines."

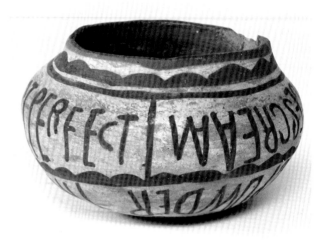

55. Acoma pot
1910-1920
Handbuilt and slip-painted; clay
White, black, red-brown
11.75 h.×12.25 dia. in. (29.3×30.6 cm.)
Cusick acquired this pot from a family of collectors that had strong ties to the Indian culture of the Southwest. The father of the family was a chef on the Santa Fe Railroad, who married a "Harvey girl," a waitress at a Fred Harvey restaurant. The Harvey trading post and chain of hotels and restaurants played a central role in the marketing of Indian art at the turn of the century.

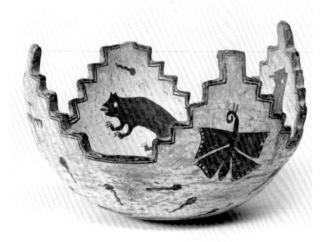

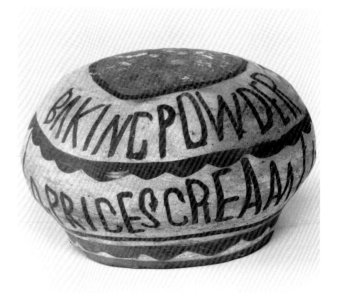

56. Zuni ceremonial bowl
1825-1850
Handbuilt and slip-painted; clay
White, brown, red-brown
6 h.×9 dia. in. (15×22.5 cm.)
This is one of the oldest pots in Martha Cusick's collection, and one of her most treasured pieces. It was made for ceremonial purposes. The stepped-rim form was common for sacred bowls at Zuni, but not at

57. Hopi "Polaca polychrome" bowl
1860-1890
Handbuilt and slip-painted; clay
White, brown
3 h.×5 dia. in. (7.6×12.7 cm.)
The inscription on this bowl reads, "DR. PRICE'S CREAM, MADE THE MOST PERFECT, BAKING POWDER, 1/2 THE FULL WEIGHT." The inspiration was probably an object brought into the Hopi community from the outside American culture. The bowl reflects the sometimes curious interfaces and juxtapositions between the Indian and non-Indian worlds, and appeals to the collector both for its humor and its poignancy. It speaks to Cusick's interest in what is sometimes considered American Indian folk art, and to her delight in figurative imagery.

Dextra Quotskuyva Nampeyo is the great-grand-
daughter of Nampeyo, the woman credited with
beginning the revival of Hopi pottery one hundred
years ago. The tradition was passed on directly
through the family and now extends to Dextra's
children.

Martha Cusick has built a strong friendship
with the artist, and cares deeply about her and her
work. She has sponsored several showings of Dex-
tra's pots. In 1984 Cusick brought her love and
respect to "Nampeyo: A Gift Remembered," an
exhibition at the Mitchell Indian Museum in
Evanston, Illinois. As curator, she searched muse-
ums and private collections for examples of
Nampeyo's historic pieces, and brought them
together with selected examples of her descendant's
work. Each of Dextra's pots was presented in the
exhibition with her personal comment about its
meaning and history.

58. Dextra Quotskuyva Nampeyo (Hopi), sherd design seed jar
1980
Handbuilt and slip-painted; clay
Tan, red-brown, black
3.5 h.×13 dia. in. (8.75×32.5 cm.)
The incredibly intricate designs on this pot were inspired by ancient
pottery sherds found on the Hopi reservation. Old designs, sometimes
outlined in the actual shape of the broken pieces, are combined with
new and innovative motifs. The artist claims the pot represents the
unity of people: "there's everything in there, the whole universe." She
has made just a few of these pots, and this is one of the finest. It is,
furthermore, a pivotal piece in the Cusick collection. (Color
plate, p. 36)

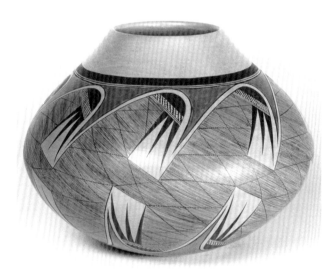

59. Dextra Quotskuyva Nampeyo (Hopi), fine line jar
1979
Handbuilt and slip-painted; clay
Tan, black, red-brown
7.25 h.×10.12 dia. in. (18.1×25.3 cm.)
The fine lines applied to the surface of the pot with a yucca fiber brush
represent a "migration" design. The artist quoted her mother as saying
it reflects "the way people moved around the continent." (See also 101
in the Hootkin collection.)

The animal and human figures made at Cochiti at
the end of the nineteenth century are the historical
antecedents of Helen Cordero's work (see Marsik
37, 38 and Hootkin 102–104). Cochiti artists also
made pots, but figures were most popular with
buyers.

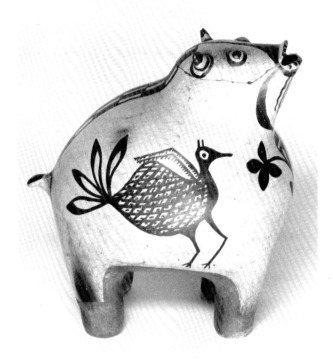

60. Cochiti bull figure
1880–1890
Handbuilt and slip-painted; clay
Beige, black
14 h.×12.5 l.×10 d. in. (35.6×31.8×25.4 cm.)
This bull has been ceremonially "fed" with grain or meal, and still con-
tains the food.

62. Navajo (?) hichi necklace with silver pendant
c. 1900
Hand-fashioned clamshell beads; cast silver with turquoise inlay
16 l. in. (40.45 cm.)

63. Navajo (?) silver necklace with pendant
c. 1880
Hand-formed silver beads; hand cast silver crosses; wool wrap
15 l. in. (37.75 cm.)
These necklaces represent early examples of Southwest Indian silverwork. The double-barred cross was a native modification of the caravaca cross, introduced to the area by Franciscan priests. The Puebloans associated the double cross motif with the dragonfly, which connoted fertility and abundance. Cusick had had these pieces for many years when she found the photograph, "The Black Jar," in which an Indian woman is wearing the same hichi shell piece.

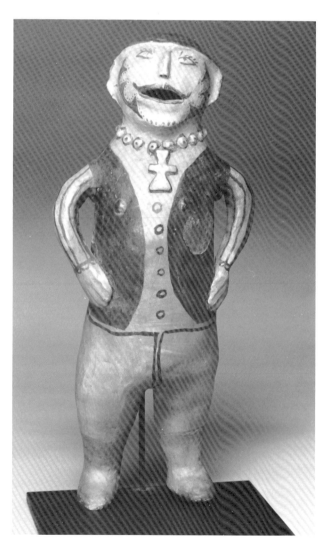

61. Cochiti human figure
c. 1880
Handbuilt and slip-painted; clay
Beige, black
15.5 h.×6.25 l.×4 d. in. (38.75×15.6×10 cm.)
To attract tourists to his curio shop in Santa Fe, trader Jake Gold encouraged Cochiti potters in the mid 1870s to expand their figurine tradition. He didn't tell them what to make. The often satirical caricatures that the artists came up with embody their perceptions of outsiders. This figure is meant to be a representative of Anglo or Hispanic culture, and may be a circus performer. He is depicted wearing a bead necklace with a cross that is similar to the necklaces in the Cusick collection (62 and 63).

64. Karl Moon, "The Black Jar"
1914
Photograph
16.75 l.×13 w. in. (42.6×33.1 cm.)
"The Black Jar" is typical of "artistic" photographs taken of the "vanishing" Indian people in the early part of the century in that the images are posed, Indian artifacts are used as dramatic props, and unrelated traditions are blended indiscriminately.

The Little Eagle Family Collection

Roger and Bernardine Little Eagle (Tallmadge) set up a basket/beadwork stand near their home in Wisconsin Dells shortly after their first child was born in 1953. Within three years they had built rooms onto the house and opened a regular shop. From the beginning, they used it to display the Indian artifacts that Mr. Little Eagle had always loved to collect. Since people enjoyed coming to this rather informal museum, the Little Eagles were encouraged to add more and more items for display. They sought out all kinds of Indian objects, but focused principally on things made by their own people, the Winnebago and the Sioux. Some pieces were passed on from friends or relatives, and some came in from people who were willing to trade them for Mrs. Little Eagle's beadwork, but most items were purchased directly from their Indian owners.

Extremely varied, the collection includes everything from garments and personal accessories to flutes, pipes, horse trappings, cradleboards and baskets from the Woodlands and the Plains, and pottery, kachina figures, and other assorted items from the Southwest (the family took many trips there as the children were growing up, and always brought items back with them). Since "digging" was another family pastime, the collection also includes a vast array of arrowheads and other archeological artifacts. "We'd take a day off and go arrowhead hunting," one son explains. "If we passed by what looked to be a possible old village site, we'd pull off on the side of the road, and everybody would jump out of the car and start walking the fields. With four or five of us we could cover quite an area in a short time."

The collection has been a family venture in other ways as well. Everyone participated in the building process as the museum/store complex grew, and other relatives also pitched in. The children remember sitting with them and peeling the logs for the timbers, or helping to paint the walls. There was "a lot of joking and laughing . . . that was an enjoyable time." The collection was an integral part of their family life, then, and was part of the context in which the children grew up. They participated in decisionmaking about the pieces and their display, and joined their parents in the store as soon as they were old enough. When Mr. Little Eagle died suddenly in 1979, they continued to work there with their mother.

Family associations also blend in this case into Indian identification and tribal pride. The Little Eagles see themselves as Indian people trying to preserve their culture. They have helped keep many items in Indian hands and thus ensured that they get the "spiritual care" they deserve. They have also introduced the items to non-Indians who often have had little exposure to the wealth of artistry in Indian life, and helped them understand something about the Indian past. And, they communicate, by their very presence in the museum, the fact that Indians are a part of the present—are modern, sophisticated individuals who participate in American society and initiate and succeed in their own business ventures.

Asked what the collection means to her, Mrs. Little Eagle immediately replies, "hard work." This rather humorous response does not mean, of course, that the pieces are not the source of pleasure, emotion or spiritual sustenance. It means, rather, that just as there was no real separation between the functional and the aesthetic in Indian life, so too has there been no real separation between these pieces and daily life in the Little Eagle household. The objects are a fact of life for them, an ongoing presence. They have not only built up or had this collection; they have "just been living it."

By the turn of the century, the bandolier bags of the Great Lakes Indians (see also 51) had become large and fully beaded. Both men and women wore them, and for a particularly magnificent effect they used two at once (one rode on each shoulder; the straps crossed in front). Because they were such important display pieces, bandolier bags have been preserved by many Indian families. These two examples came to the collectors from Winnebago individuals, although they are worked in a style more often associated with the Chippewa. The neighboring tribes exchanged both actual objects and design ideas, and the bags would have been prized by either of them.

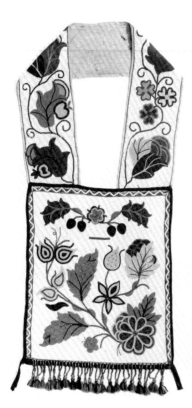

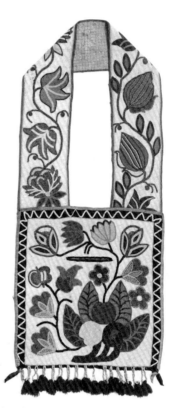

65. Winnebago (Chippewa?) bandolier bag
c. 1900
Spot-stitch applique beadwork; cotton, glass beads, wool, silk
White, green, blue, pink, red, yellow, silver and gold beads
41.6 l.×17.2 w. in. (105.7×43.9 cm.)
"Bags" like this were showpieces rather than practical containers; this one does not even have a pouch of any kind.

66. Winnebago (Chippewa?) bandolier bag
c. 1900
Spot-stitch applique beadwork; cotton, glass beads, wool, silk
White, translucent, green, blue, red, pink, black, yellow, and gold beads
44.5 l.×18 w. in. (113×45.7 cm.)

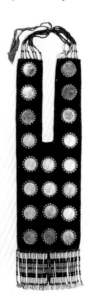

67. Yankton-Sioux neck ornament
c. 1950
Sewn and appliqued; velveteen, mirrors, glass and wooden beads, aluminum "play money"
Navy ground; white, red, gold, black and yellow beads
44.25 l.×12.5 w. in. (112.3×31.8 cm.)
This piece is something of a mystery. It was undoubtedly made as a type of personal adornment and is similar in concept to the bandolier bag. It may, however, have been worn in a frontal rather than over-the-shoulder fashion. Other mirrored neckpieces were called "ponchos," and recent examples were made of beaver pelt. Although the materials are unusual and almost humorous (they no doubt represent what was readily available to the artist; the coins are marked "play money" and the mirrors, which are backed with U.S. Army insignia, may have been army-issue), the piece has the same rhythmic sensitivity and excitement as the beaded dress (74), and must be imagined as it looked on a dynamic, moving body.

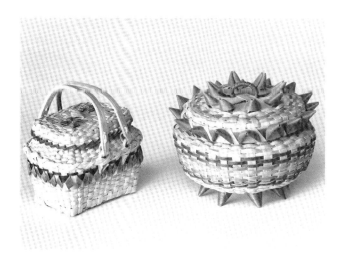

68. Elvina Decorah (Winnebago), miniature lidded basket with handles
1976
Woven; black ash splint
Undyed and dyed (brown, yellow) fibers
1.75 h.×2.6 w.×2.25 d. in. (4.5×6.7×5.8 cm.)

69. Elvina Decorah (Winnebago), miniature "strawberry" basket
1976
Woven; black ash splint
Undyed and dyed (yellow, red, brown) fibers
2.75 h.×3.5 dia. in. (7×8.9 cm.)
Mrs. Little Eagle would like to have at least one example of the work of every active Winnebago basketmaker in her collection. While these miniatures (see also 18–21 in the Van Zelst collection) are valued primarily for their aesthetic integrity and technical virtuosity, the Little Eagles do use many of their baskets, and treasure them all the more for their serviceability.

The heydey of beadwork among the Western Sioux and other Plains tribes was from about 1865 to 1900. Small glass beads were readily available once white settlers came to the Sioux territory, and the Indian women began to use them in exuberant new ways.

Items of all kinds—clothing, horse furnishings, baby carriers, containers of all types—were soon solidly covered in beadwork, usually with a multicolored pattern set against a white background.

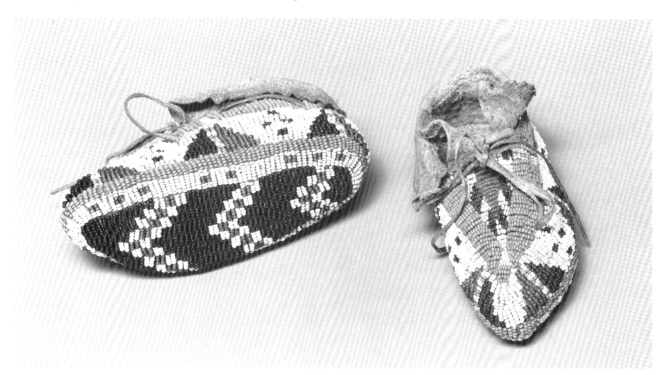

70. Sioux child's moccasins
1875–1890
Lazy stitch applique beadwork; deerskin, glass beads
Undyed deerskin; white, navy, red and yellow-green beads
5.5 l.×2 w.×2 h. in. (14×5.1 cm.)
Moccasins of this type, with beading on the sole as well as the upper area, are said to have been funereal items, made to be buried with the owner. This assertion has been shown to be erroneous; the beaded soles were indeed impractical for everyday wear, but were for use on special occasions.

71. Sioux pipe bag
Late 19th century
Lazy stitch applique beadwork, deerskin, glass beads, horse hair, tin
Undyed deerskin; dyed horsehair (red); white, red, blue and green beads
27.8 l.×8 w. in. (68.5×20.3 cm.)
Pipe bags were traditionally used to store long-stemmed ceremonial pipes. They were strongly identified with their owners, and pipe bags that have come through the family are among the most highly valued items in the Little Eagle Family collection. (Color plate, p. 37)

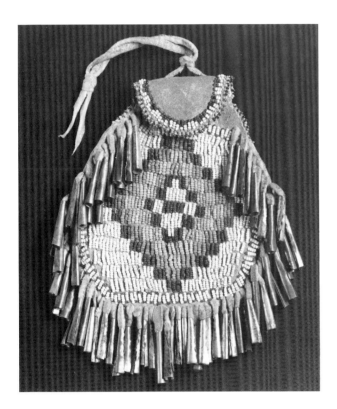

72. Sioux woman's bag
Early 20th century
Lazy stitch applique beadwork; deerskin, glass beads, tin
Undyed deerskin; white, navy, yellow-green, red, yellow and pale
blue beads
7.25 l.×6 w. in. (18.5×15.3 cm.)
This bag seems to represent a hybrid form: it is related to traditional
bags that Sioux women used to carry flint (and in the later period, gov-
ernment ration tickets), but it appears to be influenced by the type of
purses that turn-of-the-century white women carried. Possibly, it was
even made for a white settler who requested it. Bags and other Plains
area beaded objects of this sort never caught on in the sa ne way that
baskets and rugs did in the collecting craze of the turn r. the century.

73. Sioux horse (saddle) blanket
c. 1885
Lazy stitch applique beadwork; cotton, silk, glass beads, deerhide, bells
Brown cotton; red silk; white, blue, gold, red, yellow and green beads
79.25 l.×25 w. in. (201×63.5 cm.)
A large number of beads went into an item of this kind, and a great
deal of time was involved in its execution. Understandably, it was a
much-treasured, high-status object. There is some speculation that
motifs like the ones seen here may have been influenced by the patterns
of Oriental rugs.

74. Sioux child's dress
Late 19th century
Sewn and appliqued; wool, cotton, dentalia shells, cowrie shells, elk's
teeth, glass beads
Navy ground; white applied elements
34.5 l.×28 w. in. (87.5×71.9 cm.)
This dress is similar to a full size garment Mr. Little Eagle gave his wife
when they were first married. Both dresses represent the kind of blend-
ing of white and Indian materials and forms that were common among
the Plains Indians in the reservation period (see also 49 and 51). The
child who wore this piece must have been dearly loved, for the elk's
teeth were very hard to come by and costly. The rows of teeth, shell,
and beads that make up the decorative elements create rhythmical sta-
catto patterns that accentuate the wearer's movements.

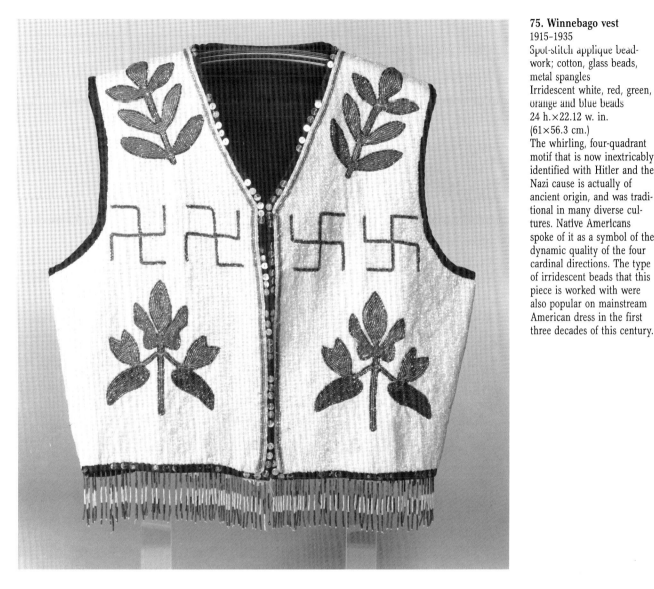

75. Winnebago vest
1915–1935
Spot-stitch applique bead-work; cotton, glass beads, metal spangles
Irridescent white, red, green, orange and blue beads
24 h.×22.12 w. in. (61×56.3 cm.)
The whirling, four-quadrant motif that is now inextricably identified with Hitler and the Nazi cause is actually of ancient origin, and was traditional in many diverse cultures. Native Americans spoke of it as a symbol of the dynamic quality of the four cardinal directions. The type of irridescent beads that this piece is worked with were also popular on mainstream American dress in the first three decades of this century.

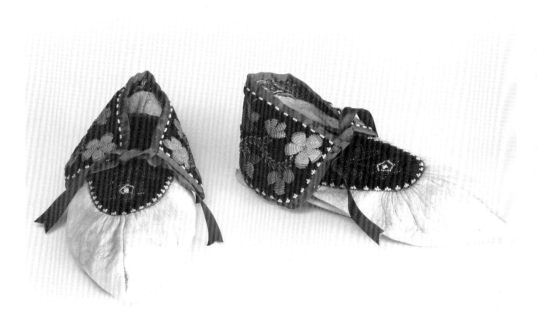

76. Chippewa moccasins
c. 1970–1980
Spot stitch applique bead-work; undyed deerskin, glass beads, gros-grain ribbon
Pink, black, brown and gold beads; purple ribbon
12 l.×5.12 w.×3.75 h. in. (33.5×13×9.5 cm.)
Chippewa and other Great Lakes Indians have continued through the twentieth century to make moccasins in their traditional tribal styles. Aesthetically pleasing Indian footwear is especially meaningful at pow-wows, which are important occasions and markers of cultural identity in contemporary Woodland Indian life.

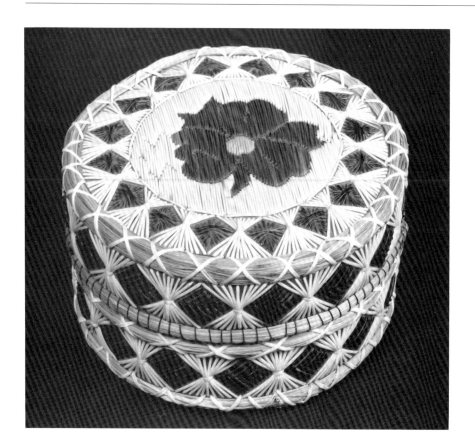

77. Ottawa quilled box

20th century
Applied quillwork; birchbark, porcupine
quills, sweetgrass
Undyed (white) and dyed (purple, green,
yellow) quills
3.25 h.×6 dia. in. (8.3×15.2 cm.)
Quill-decorated birchbark boxes were pro-
duced in the Northeast Woodlands as trade
items as early as the eighteenth century.
Few individuals are still making them today.
To create the designs, porcupine quills are
inserted one by one into softened bark, and
are bent back at both ends, rather like a sta-
ple. Boxes like these can in some senses be
considered equivalent to the treasure or gift
baskets of the West Coast Indians (see 15,
16, 27 and 28).

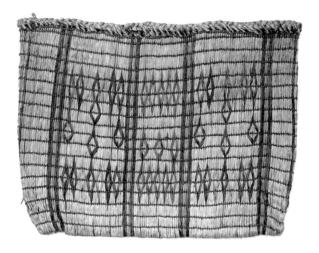

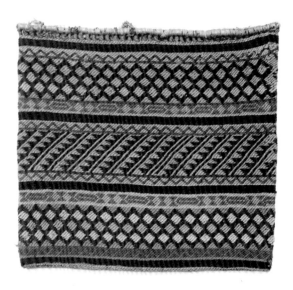

78. Winnebago basswood bag

20th century
Twined; basswood bark
Undyed and dyed (green, purple) fibers
11.5 h.×15.75 w. in. (29.2×40 cm.)
Strips of the inner bark of the basswood tree were softened, twisted,
and twined into this simple but elegant bag. Such bags were standard
storage containers in the Great Lakes area in the pre-contact period, and
illustrate the ingenuity with which the Indians used the materials
around them. This piece was probably made in the twentieth century,
following age-old techniques. It is prized by the Little Eagle family
because it represents the richness of their heritage.

79. Winnebago yarn bag

Late 19th-early 20th century
Twined; wool, cotton
White cotton; purple, turquoise, gold, black, red and pink wool
17.5 h.×19.75 w. in. (44.5×49.9 cm.)
The yarn bag evolved as a later adaption of the basswood bag tradition
(see 78); easily available commercial yarn was substituted for the bass-
wood strips, but the technique remained the same and the bag retained
its rectangular shape. The Winnebago love color and like to use it
exuberantly (see also 23 and 75).

The Busse Collection

Curtis and Myrtle Busse began collecting Navajo rugs in 1950 when they returned to the West fifteen years after spending time there when they were first married. Their first purchased rug was seen as a part of the western experience. The majority of the Busses' pieces were acquired later, when weaving blossomed after 1970. They are interested strictly in contemporary rugs, which they believe are as fine as any produced in earlier periods, and they feel that every time they buy a rug they are "giving a boost" to both the art of Navajo weaving and the individual artist who made it. They are proud of spending their money this way. Sometimes the collectors buy rugs to give as presents—"a wedding is an excuse to give a rug away so you can go and buy more"—and they estimate that over the years they have given about one hundred such gifts. They also have a core of pieces that they "selfishly hang on to," however, and it is those rugs that really constitute their collection.

The collection is designed to be representative, that is, the Busses attempt to include high-quality examples of all the current design types. They enjoy comparing variations within recognized styles, and even keep a few examples of mediocre and imitation rugs for purposes of comparison. They love to share the collection and delight in any opportunity to educate people about the artistry of contemporary Navajo weaving, but have been tentative about going much beyond their local area, and are scornful of people who are interested in rugs solely for purposes of investment. They categorically state that they collect rugs for "the fun of it."

The Busses make regular trips to the Southwest and keep well abreast of developments in the weaving community. They get most of their rugs from a particular dealer, but they also like to attend auctions "for the spectacle" and the opportunity to see what specific weavers are up to. The collectors do not buy directly from any of the artists, largely because they do not wish to appear pushy or insensitive. They stay in the background, quietly building their collection, thereby encouraging the perpetuation of the work they love and seeing that representative examples make their way out into the world for others to see and enjoy.

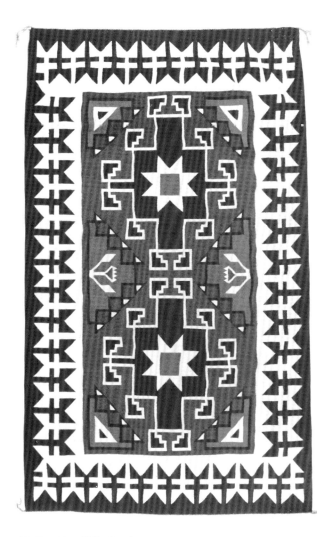

80. Two Grey Hills Navajo rug
1935-1950
Woven; wool
Undyed (white, brown, black)
88 l.×50 w. in. (220×125 cm.)
This rug was the first the collectors purchased. It was chosen for them by a Colorado dealer who wanted to "start them out right" with what was then a "collector quality" rug rather than a souvenir. Two Grey Hills rugs, which were known for their natural (undyed) wools and their tight weave, set the standard at the time for quality Navajo weaving. Unlike many that were made later, this piece was intended to be used as a floor covering.

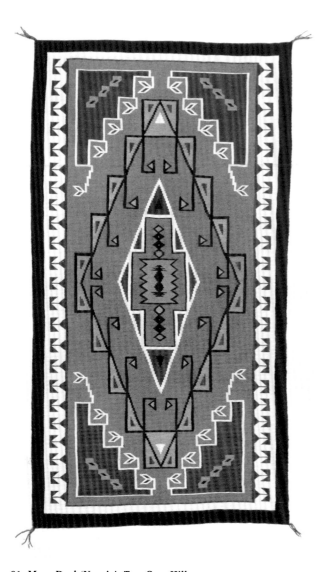

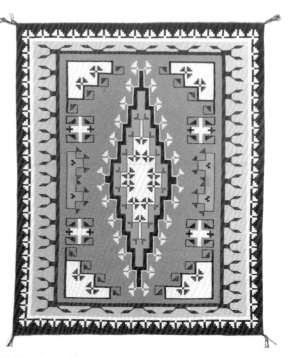

83. Mae Begay (Navajo), Teec Nos Pos style rug
1965-1970
Woven; wool
Undyed (white, gray) and dyed (gray, green, black, brown)
60.5 l.×48 w. in. (151.25×122 cm.)
Although the artist comes from the Teec Nos Pos area, this rug incorporates patterns from the Two Grey Hills style. This kind of blending of styles has become common in Navajo weaving since the pickup truck has become an integral part of Navajo life. With increased mobility, even remote areas are no longer isolated and weavers have continued to expand their repertoire and explore new patterns and forms of expression.

81. Mary Deal (Navajo), Two Grey Hills rug
1970-1975
Woven; wool
Undyed (white, gray, brown) and dyed (black)
69.5 l.×37.5 w. in. (173.5×93.75 cm.)
By the time this Two Grey Hills rug was woven, finer yarn was used and the piece was meant to function more as a tapestry than a rug.

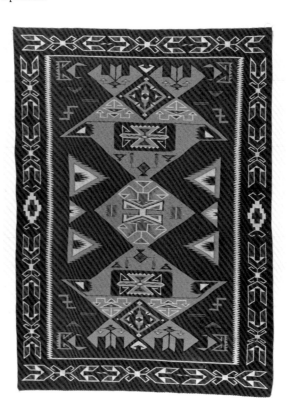

82. Clara Nelson (Navajo), Teec Nos Pos rug
1982
Woven; wool
Undyed (white) and dyed (red, blue, black, brown, gray, beige, green, orange)
76 l.×53 w. in. (140×132.5 cm.)
On the Teec Nos Pos area of the Navajo reservation, traders encouraged an intricate patterning that was influenced or based on Oriental rugs. Multicolored designs were often favored. Clara Nelson, the daughter of a noted Teec Nos Pos weaver, was twenty-four years old when she made this piece. Not many rugs of this intricacy and quality are woven in this design in such large sizes.

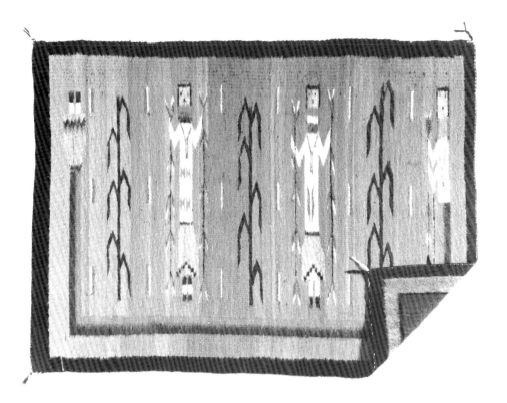

84. Bertha Bennally (Navajo), double-faced rug
1974
Double woven; wool
Undyed (white, gray, brown, black) and dyed (green, gold, black, turquoise, red-orange)
37.5 l.×50 w. in. (95.3×127 cm.)
Double-faced rugs are quite rare because the technique is difficult and exacting. Two completely different designs are created with a single layer of fabric. Bennally's piece is especially unusual because each side has an equally intricate design. The rug has been brushed to give it its soft quality. The Busses are proud that their collection includes a piece of this type.

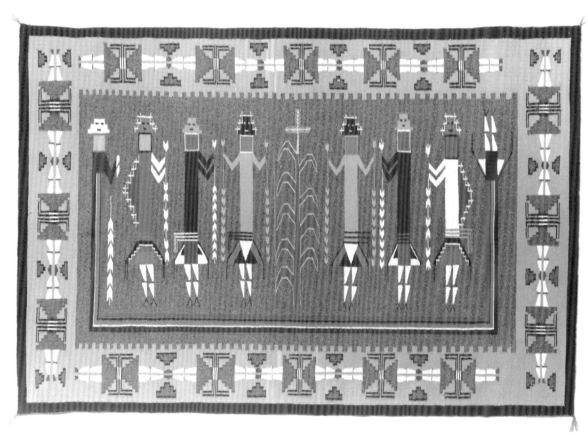

85. Shirley David (Navajo), Yeibichai rug
1975-1980
Woven; wool
Undyed (white, gray, brown) and dyed (gold, gray, brown, red, rose, green, blue)

45 l.×66 w. in. (112.5×165 cm.)
The figures on the field of this rug are inspired by ceremonial figures from the Navajo Fire Chant. The border design is made up of the repeating motif of the kilts and legs of the figures in the central field. The gold color in the border is also unusual.

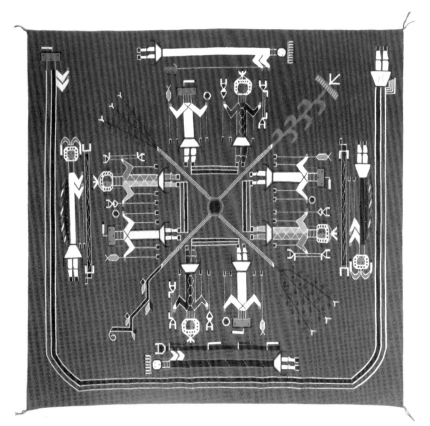

86. Mary Long (Navajo), "Whirling Logs" sandpainting design rug
1981
Woven; wool
Undyed (white, gray) and dyed (brown, black, gold, green, blue, red)
62 l.×64 w. in. (155×160 cm.)
Sand "paintings" are created from grains of colored sand, pollen, and related materials as part of Navajo healing ceremonies. "Patients" sit on the designs, which are considered sacred and are always destroyed after the ceremony is over. Most authorities feel that sandpainting designs were first translated into weavings about 1920, although there are sporadic references to even older pieces. The rugs are not sacred in any way. Only a few highly skilled weavers work with the demanding design, and though the sandpainting rug is now an established Navajo tradition, it is still not commonly used. Long comes from a family of sandpainting weavers, and is known as a master of this form. The collectors looked for many years for a rug from her family, and consider this work one of their outstanding pieces.

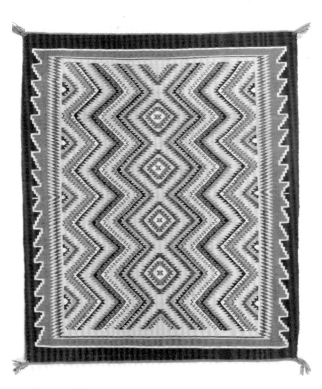

87. Ida Bennally (Navajo), rug
1975–1985
Woven; wool
Undyed (white, brown, beige, black) and dyed (gold, brown, beige)
45 l.×37 w. in. (112.5×92.5 cm.)
This piece combines an eye-dazzler type pattern (see 48 in the Marsik collection) with the soft, natural-dyed colors that were introduced in some areas in the twentieth century.

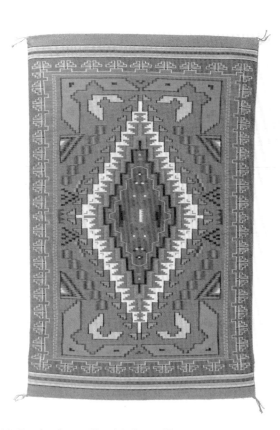

88. Roselyn Begay (Navajo), Burnt Water rug
1983
Woven; wool
Undyed (white, gray) and dyed (brown, purple, rose, beige and gold)
59 l.×37 w. in. (149.9×94 cm.)

89. Rena Berchman (Navajo), Wide Ruins rug
1986
Woven; wool
Undyed (white) and dyed (gray, brown, yellow, coral)
38.5 l.×30.5 w. in. (96.25×76.25 cm.)
(Color plate, p. 38)

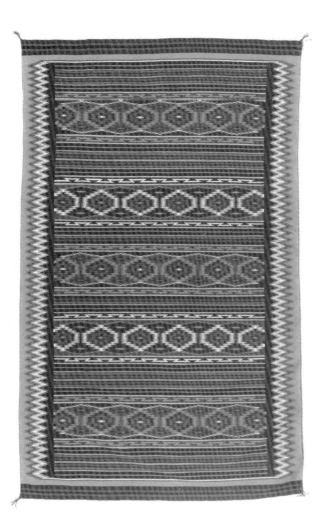

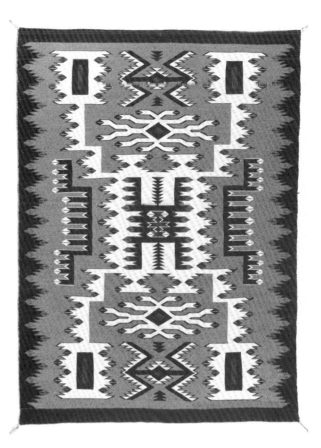

90. Jennie Thomas (Navajo), Wide Ruins style rug
1986
Woven; wool
Undyed (white) and dyed (green, brown, orange, red-brown)
66 l.×40 w. in. (165×100 cm.)
Rugs from the Burnt Water and Wide Ruins areas are known for their fine weave and vegetable dyes. Wide Ruins styles originally maintained the borderless format of the Chief's Blanket (see 43 and 44), which evokes the endless quality of the landscape. Jennie Thomas, a young weaver, varied the tradition by adding multiple decorative borders.

91. Betty Curley (Navajo), raised outline rug
c. 1985
Woven; wool
Undyed (white, brown) and dyed (brown, black, red, gold, blue)
45 l.×30 w. in. (112.5×75 cm.)
A raised-edge outline is created around the pattern on the front of this rug by means of an overshot weave. Betty Curley is one of the few artists who works in this exacting technique, and the collectors have made a point of including a rug of this type in their collection.

92. Bessie Sellers (Navajo), storm pattern rug
1974
Woven; wool
Undyed (white, gray) and dyed (black, red, brown)
64 l.×47 w. in. (160×117.5 cm.)
The collectors treasure this piece because it is one of the most ornate versions of the storm pattern they have seen. The storm pattern design includes many representational elements: four corner squares representing the four mountains bordering the original Navajo territory; "lightning" bolts connecting the mountains to a central hogan or home; and pairs of stylized water bugs at opposite ends of the rug.

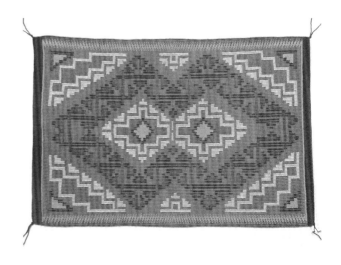

 The Hootkin Collection

Larry and Jane Hootkin made their first trip to the Santa Fe area in 1970, when Dr. Hootkin was stationed at an army hospital in El Paso. They were immediately taken with the atmosphere of the area—the light, the landscape, and most of all the indigenous way of life. They bought a piece of black Santa Clara pottery as a symbol of that visit. Soon the drive from Texas to New Mexico became a ritual; every time there was a three-day pass, they packed their children into the car and took off.

The trips were often structured around art. They familiarized themselves with area artists, and quickly learned what constituted quality work. They then set out with particular goals in mind—to find a Maria (Martinez) pot, to meet Grace Medicine Flower. Each trip became more consuming and more exciting and yielded new friends and new artworks.

The Hootkin collection focuses on contemporary Southwestern Indian art, much of which still comes from the Santa Fe region. It includes pottery, sculpture, and paintings, all of which embody the feeling of the land and its people. When asked how they characterize their collection to others, they say it describes the people and the way of life that it represents. The collectors had been exposed to a great deal of art when they lived on the East Coast, but they explain that nothing had ever affected them the way these pieces do. They respond strongly to the fact that the Indian potter thanks Mother Earth for her clay and promises her she will make something beautiful; they feel that reverence and that promise in the finished pot. Some of their pieces are in fact not made by Indians, but all explore Indian or area themes, and all convey the same feeling. They have, for example, a significant collection of paintings by Paul Pletka, an artist who is not an Indian himself but whose work cuts to the heart of the Indian experience. Their pieces must "speak" to them, they say, but they must also represent the very best of the artist's work.

The Hootkins have developed close friendships with many of the artists whose work they collect. Grace Medicine Flower "befriended" them on one of their first trips to the area, and they became so close to Helen Cordero that they felt like part of her family. They have shown up for pottery firings at 5:00 a.m. and have spent hours making tortillas in Indian pueblo kitchens. They have the kind of relationship with Paul Pletka that enables them to ask him for an original drawing for an anniversary present. (About ten percent of the pieces in their collection were made expressly for them.) These friendships have been maintained for nearly twenty years, for even though the collectors moved back to Wisconsin when the service commitment in Texas was completed (they personally transported their pots back with them, for they could not be trusted to any movers), they return to the Southwest several times a year and remain actively involved with communities there.

The intensity and importance of the Hootkins' collecting experience is immediately evident when one enters their home. The artworks dominate the house and bring a feeling of the Southwest to the shores of Lake Michigan. They feel strongly that all the pieces should be seen and enjoyed again and again, and indeed, they are so aware of them at all times that Dr. Hootkin will notice if a pot has been moved a few inches. The artworks make the home for the Hootkins; there were years when they had little furniture, they explain, but they had many wonderful things on the walls. The collection is a shared experience, a bond, and it stands as a kind of testimony to the life they have built together and the values and attitudes they hold. The Hootkins call their collection "a major outlet," an identity that is separate from their day-to-day life or their professional activities. It is something they like to return to, over and over again. It is, as they so clearly understand, a source of joy.

93. Doug Hyde (Nez Perce/Chippewa/Assiniboin), "The Travelling Tipi Salesman"
c. 1975
Carved; limestone
Light gray
15 h.×13.75 w.×8.75 d. in. (37.5×34.4×21.9 cm.)
The Hootkins are enthusiastic about Doug Hyde's work, which combines a western sculptural tradition with Indian themes and sensitivities. Hyde is native to the Northwest, but moved to the Southwest in the 1960s, and remains in that area. His work is in museum collections throughout the country, and he has made an impact in the Southwest Plains, and western art circles. He likes to work with the stories and myths of his people because "their visual interpretations have not been concretized," and they permit him much creative freedom. He allows the stone to determine much of the form, texture and feeling of the final design of each piece.

Nancy Youngblood Cutler (Sarafina Tafoya's great-granddaughter and kin to Margaret Tafoya [97] and Grace Medicine Flower [98]) has become a much sought-after Santa Clara artist. She works almost exclusively on a miniature scale, and has an impressive mastery of tiny detailing. The collectors respond to the "elegance" of this meticulous work, and display a grouping of her pieces in one of the most prominent places in their home. They also have a strong relationship with the artist, have attended several of her firings, and are regularly in touch with her.

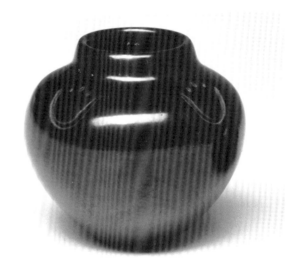

94. Nancy Youngblood Cutler (Santa Clara), miniature pot
1982
Handbuilt, carved and burnished; clay
Black
2.36 h.×2.12 dia. in. (6×5.5 cm.)
This pot won first prize at the 1982 Indian Market in Santa Fe, where the collectors acquired it. The market opens early in the morning and artists often have only a few pieces for sale, so interested collectors start queuing up for their work the evening before. Larry Hootkin and his son were the first to arrive at Youngblood Cutler's booth in 1982, and waited there all night long. They were able to get first choice of the pieces that were for sale. The experience was something of a "rite of passage" in the collecting experience. The piece is regularly displayed on its first-place ribbon.

95. Nancy Youngblood Cutler (Santa Clara), miniature bear claw pot
1979
Handbuilt, carved and burnished; clay
Black
1.5 h.×1.75 dia. in. (3.8×4.5 cm.)
See 97 for a discussion of the bear claw pot tradition.

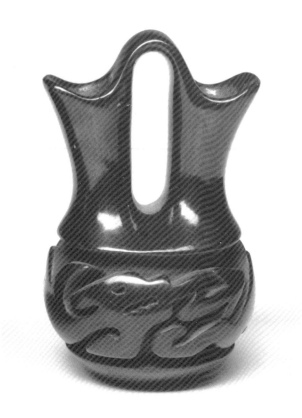

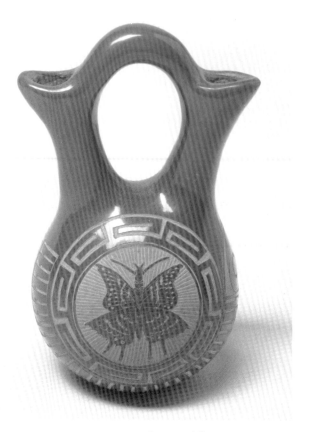

96. Nancy Youngblood Cutler (Santa Clara), miniature wedding vase
1979
Handbuilt, carved and burnished; clay
Black
2 h.×1.25 dia. in. (5.1×3.2 cm.)
The wedding vase or jar (see also 98) is a traditional Santa Clara form which has been shown to have antecedents in pre-Columbian Peru. In Santa Clara it has been used ceremonially as part of the exchange of wedding vows: the bride drinks from one side and the groom drinks from the other. This piece was also purchased directly from the artist. The motif on the body represents a water serpent.

98. Grace Medicine Flower (Santa Clara), wedding vase
1980
Handbuilt, incised and burnished; clay
Red
3.5 h.×2.25 dia. in. (8.75×5.6 cm.)
Grace Medicine Flower grew up in a distinguished family of potters (she is Margaret Tafoya's [97] niece), and follows forms that have been used for generations in her community. Her fine incised (sgraffito) designs are executed after the pot is burnished.

The Hootkins also count Medicine Flower as one of their special friends. They not only visit her regularly (she "always" wants to take them to dinner when they are in Santa Fe), but have had her to their house as well. On one of their visits they brought Helen Cordero and her husband to Santa Clara to meet Medicine Flower—the artists live only forty-five minutes apart, but had never met.

Medicine Flower made this vase especially for the Hootkins when she learned that they had acidentally broken another of her pots (see also 96 for another wedding vase).

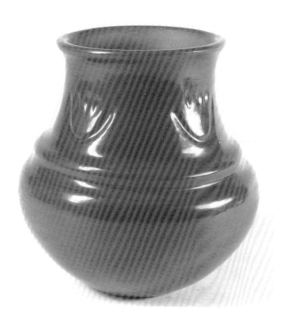

97. Margaret Tafoya (Santa Clara), bear claw pot
1983
Handbuilt, carved and burnished; clay
Red
9.36 h.×10 dia. (23.8×25.4 cm.)
Margaret Tafoya learned pottery-making from her mother Sarafina, and she in turn is the mother of eight children who are potters in their own right. She is, consequently, one of the leading figures in contemporary southwestern pottery. Tafoya explains that the bear claw (paw) motif is a good luck symbol, as the "bear always knows where the water is." The motif, echoed in miniature in her granddaughter Nancy Youngblood Cutler's piece (95), is also evident in the 1914 Karl Moon photograph (64).

99. Tony Da (San Ildefonso), bear figure
1970-1980
Handbuilt and carved; stone inlay; clay, turquoise, coral, shell, stone
Beige, red, white, turquoise
2.5 h.×4.3 l.×3 d. in. (6.4×10.8×7.6 cm.)
Tony Da received national recognition in the 1960s as a painter, but
after moving in with his grandmother, the well-known potter Maria

Martinez, in 1968, he began working with clay. He works with techniques learned from his family (his father was also an important potter), but he has added many touches of his own. The use of inlay materials and contrasts between smooth and rough-textured areas are characteristic of his work. The same kind of synthesis is evident in his iconographic images. Here, for example, the bear, a traditional and ancient symbol of his people, is handled in a unique and contemporary way. (Color plate, p. 39)

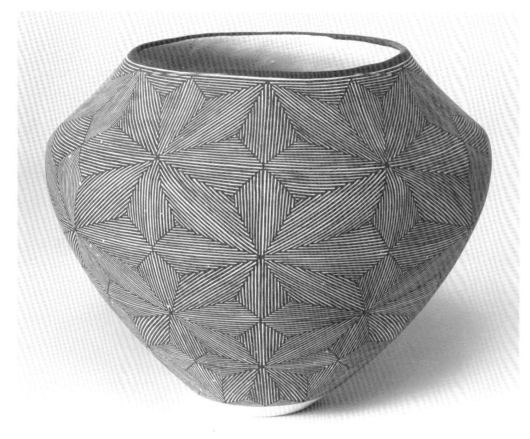

100. Sara Garcia (Acoma), fine line pot
1972
Handbuilt and slip-painted; clay
White, black
7.5 h.×9.75 dia. in. (18.75×24.4 cm.)
The collectors speak of a woman in the back room of one of the galleries they frequent in the Southwest who pulls out superior pieces only for those she considers serious buyers. This pot "emerged" for them when they proved their sincerity.

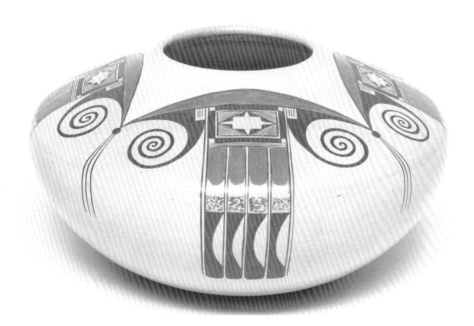

101. Dextra Quotskuyva Nampeyo (Hopi), pot
1975-1980
Handbuilt and slip-painted; clay
Tan, red-brown, brown
4.25 h.×8 dia. in. (10.6×20 cm.)
This design is based on an older Nampeyo design Dextra identified as "eagle tail." The pot was purchased from Martha Cusick.
(See 58 and 59 in the Cusick collection.)

The Hootkins, like the Marsiks, feel very strongly about their Cordero pieces. They have become so close to the artist as to feel part of her family—their children even called her "grandma" when they were young. "I look at [one of these pieces] and it means Helen Cordero to me . . . these pieces really *are* her," states Mrs. Hootkin. She points out that even the mouths on the figures are an intimate part of the artist: the characteristic open mouth is always shaped with an impression of Cordero's thumb.

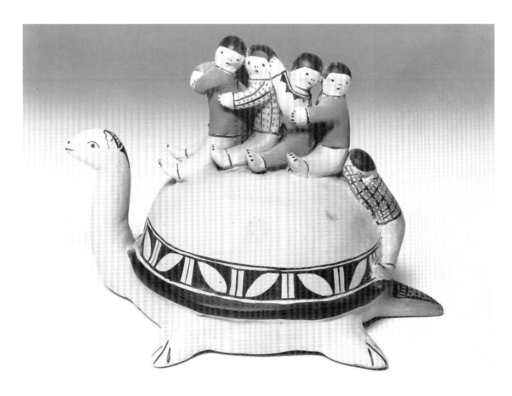

102. Helen Cordero (Cochiti), turtle figure with five children
1982
Handbuilt and slip-painted; clay
White, red-brown, black
7.5 h.×10.5 l.×7.12 d. in. (18.75×26.25×17.8 cm.)
The turtle is a relatively recent addition to the Cordero repertoire. Each child is fashioned individually and applied to the animal's back. The Hootkins also have a Cordero "Children's Hour," where twenty-five free-standing children gather around a single adult figure. It brings together the Storyteller theme (see 103) and the Creche layout or construction (see 38).

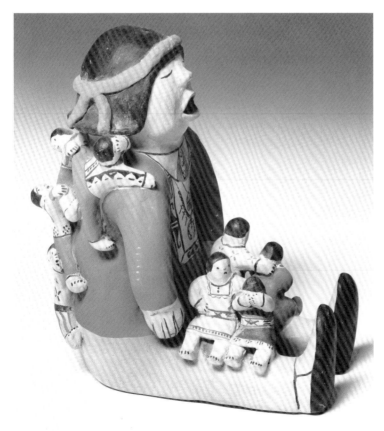

103. Helen Cordero (Cochiti), "Story Teller" with ten children
1978
Handbuilt and slip-painted; clay
White, red-brown, black
9.87 h.×8.5 l.×6w. in. (24×20.25×15 cm.)
The Storyteller has children, who are fascinated with his tales, literally "hanging on" to the words. His eyes are closed (he is thinking) and his mouth is open (he is singing).

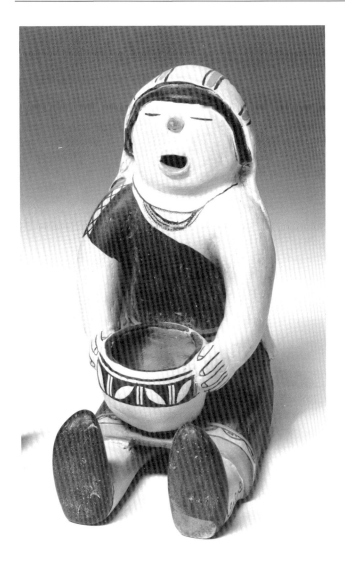

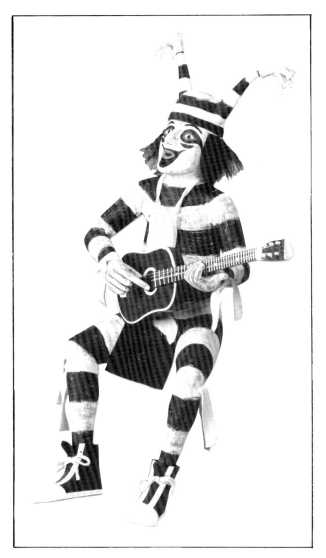

104. Helen Cordero (Cochiti), "Water Carrier"
1980–1985
Handbuilt and slip-painted; clay
White, gray, red-brown, black
10.5 h.×5.5 w.×9.5 d. in. (26.6×14×24.1 cm.)
The Water Carrier, unlike the Storyteller, is a female figure. Fittingly, she carries her water in a traditional pot. Cordero speaks of the clay as "mother," an integral part of mother earth.

105. David Phillips (Hopi), clown (koshare) figure
1985
Carved and painted; cottonwood, leather, synthetic fiber, cotton, felt
Undyed leather; black, white, and red paint
16 h.×10.5 w.×8.25 d. in. (40.7×26.7×21 cm.)
Clown or koshare associations are an important part of Hopi social and spiritual life. Clowns provide comic relief, as they do everywhere, by acting out and exaggerating human foibles and exploits. They also have a serious function, helping to maintain community harmony, for anyone who steps too far outside acceptable behavioral norms risks their public ridicule.

Phillips' clown figure reflects traditional koshare costuming and mannerisms, but its up-to-date accessories add to its humorous impact. It is carved and painted much like a traditional kachina figure, but is larger and more articulated. (Front cover)

The Smith Collection

Bob Smith, an Oneida (Iroquois) Indian from Wisconsin, first began collecting Indian art in the late 1960s, when he was working as an engineer in California. He had done a good deal of reading about his culture and recognized old Iroquois pieces when he found them in local trade shows and garage sales. Californians were interested in Northwest Coast and southwestern Indian art at the time, Smith says, but not in Woodland items. He scoured the sales for Iroquois pieces, and often spent entire days at large flea markets. Occasionally he even went out "in the dead of night" when someone asked him to come look at something right away. Most of his pieces are beadwork—beaded garments and small accessories, and an array of beaded "whimsies"—but he also picked up masks, baskets, and an assortment of other objects. Sometimes he bought non-Iroquois items with the express purpose of being able to trade for Iroquois work at a future date.

Smith's collection is very personal. When he began collecting he never thought the objects would be seen by other people, and he had no specific purpose in mind. On the contrary, he bought pieces because they "brought out something" in him and he "almost fell in love" with them. "I have an emotional and spiritual attachment to these things," he explains. "I couldn't feel that way about a car or a house, but I do about these. I am a part of them and they are a part of me." On acquiring a new piece, he sometimes moved it with him from room to room so he could fully experience it constantly.

The attachment is based on a sense of belonging, a group identification. Smith is more interested in *Iroquois* work than in the work of any particular individual, and he looks at it as a direct link to his roots. The tangible, three-dimensional objects bring his ancestors closer to him, and give him greater insight and appreciation for them. "This is not my art," he says, "but it comes from my people. [If you] pay it a compliment, [you are] really complimenting me too." He acknowledges that many, if not most, of his pieces were made for sale to non-Indians, but finds them no less meaningful for that.

The collector doesn't like to categorize his pieces; he feels they can be regarded as art, as ethnographic material, or "whatever you want." They are most important to him as part of the Iroquois past, so if they are seen primarily as art forms, they must be appreciated as Iroquois art forms; he does not want them removed from their cultural context.

Smith's collecting activity ended for the most part when he came back to Wisconsin ten years ago. Iroquois pieces were harder to find in the Midwest than in California, and he had less disposable income with which to buy those that he did find. The main reason he stopped collecting, however, was that the rather comprehensive collection felt "complete," and there was little pleasure for him in searching out new items. The insights and understanding that the collecting process had given him were brought to a related job as director of his tribal museum, and for a time some of his pieces were on display there.

Smith has made plans to sell much of his collection, for at this point he has internalized the pieces so much that he no longer needs to own them. Whether or not they remain with him in a physical sense, the pieces will remain with him in spirit.

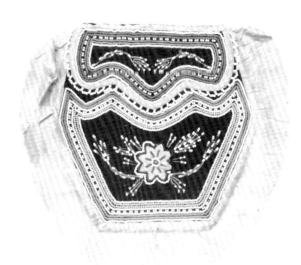

106. Iroquois woman's moccasins
Eighteenth century
Embroidered quill and beadwork; moosehide, porcupine quills, moose-hair, glass beads, silk
Undyed hide; dyed quills (orange, turquoise) and beads (white); black silk
10 l.×4 w.×3 h. in. (25.4×10.2×7.6 cm.)
These moccasins are one of the earliest examples of Iroquois work in the Smith collection, and are valued for their rarity as well as their fine design. Indians of the northeastern Woodlands embellished their every-day objects with brilliantly-dyed moosehair and porcupine quills long before the Europeans came to the continent, and items like this were avidly sought by explorers and traders, even in the seventeenth century (see p. 4).

108. Iroquois bag
c. 1850
Spot-stitch applique beadwork; velveteen, glass beads, silk
Black velveteen, pink silk; white, clear, blue, pink, green, purple and red beads
6.36 h.×7.5 w. in. (16.2×19 cm.)

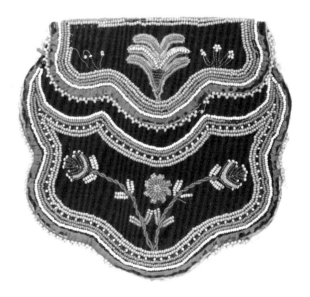

107. Iroquois (Huron?) match box or calling card case
1800–1850
Moosehair embroidery; birchbark, moosehair, cotton string
Undyed birchbark; white, green, blue, red-orange, pink, and yellow moosehair
3.75 h.×2.25 w.×.75 d. in. (8.2×5.7×1.9 cm.)
Moosehair was used in place of thread on birchbark in a unique embroidery technique probably developed jointly by native Indians and Ursuline nuns in Quebec. Finely-worked items like this were made expressly for sale.

109. Iroquois bag
c. 1850
Spot-stitch applique beadwork; velveteen, glass beads, silk
Black velveteen, red silk; pink, green, blue, gold, yellow, clear, white and red beads
5.84 h.×6.36 w. in. (15×16.2 cm.)
Illustrations of small bags like this were included in Lewis Henry Morgan's 1850 description of the Iroquois (see p. 5). Older Iroquois designs were adopted to forms that would appeal to non-Indian travel-lers, and the work found a ready market. The color scheme and basic design concept remains consistent on most of these finely-worked bags.

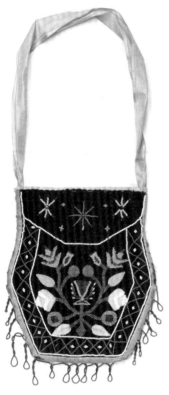

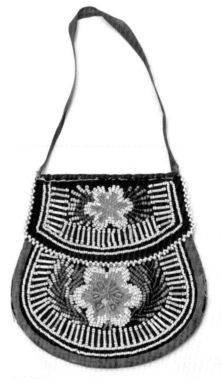

110. Iroquois bag
c. 1860
Spot-stitch applique beadwork; velveteen, cotton, silk, glass beads,
metal spangles
Black velveteen and cotton; gold silk; white, clear, pink, red, blue, gold,
yellow and green beads
8 h.×6 w. in. (20.4×15.2 cm.)

112. Iroquois bag
1860–1885
Spot-stitch applique beadwork; velveteen, wool, cotton, glass beads
Black velveteen, red cotton, brown wool; white, clear, blue, pink, red,
gold and green beads
5.75 h.×5.75 w. in. (14.6×14.6 cm.)

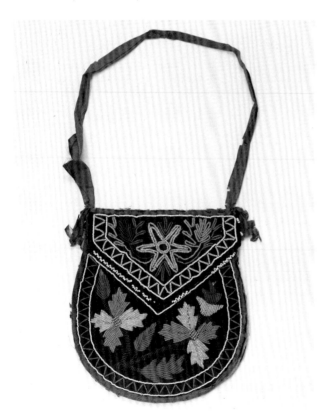

111. Iroquois bag
1860–1885
Spot-stitch applique beadwork; velveteen, cotton, silk, glass beads
Black velveteen; red cotton and silk; white, blue, pink, red, orange,
gold, yellow and green beads
6.36 h.×5.75 w. in. (16.2×14.6 cm.)
The bag tradition continued among the Iroquois tribes in the latter half
of the nineteenth century. The pieces were both sold to non-Indians and
used by the Iroquois themselves. Individual stylistic variations abound,
and no two bags are alike.

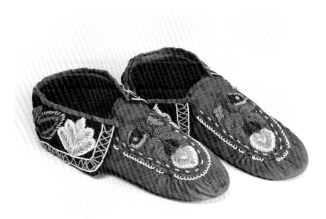

113. Iroquois moccasins
c. 1875
Embossed and spot-stitch applique beadwork; deerskin, velveteen, cotton, glass beads
Undyed deerskin, black velveteen, red cotton; white, clear, pink, red, blue, green, yellow and gold beads
10 l.×4 w.×2.5 h. in. (25.4×10.1×6.3 cm.)
Moccasins were also both worn by the Iroquois and sold as souvenirs to tourists who came to such attractions as Niagara Falls and Saratoga Springs. The same colors and design motifs were worked on other Iroquois garments, and on the ever-popular bags.

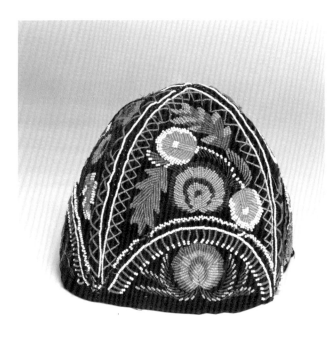

115. Iroquois domed hat
c. 1875
Spot-stitch applique beadwork; velveteen, cotton, glass beads
Black velveteen; white, clear, red, pink, blue, green, yellow, gold and orange beads
5.75 h.×7.5 dia. in. (14.6×19 cm.)

114. Iroquois brimmed hat
1875–1880
Embossed and spot-stitch applique beadwork; velveteen, wool, silk, rickrack, glass beads
Black velveteen and wool, red and green rickrack, pink silk; white, clear, red, pink, green, blue, yellow, gold and orange beads
5.5 h.×8.25 l.×8.75 d. in. (14×21×22.2 cm.)
During the fur trade era, Iroquois came in contact with Scotchmen who wore a uniquely shaped "bonnet" associated with the Glengarry region. The Indians appreciated the style, and adapted it to their own taste, applying characteristic applique beadwork in their own designs. This unusual piece adds an extra band and a brim to the basic Glengarry style to form a type of woodsman's hat. (Color plate, p. 40)

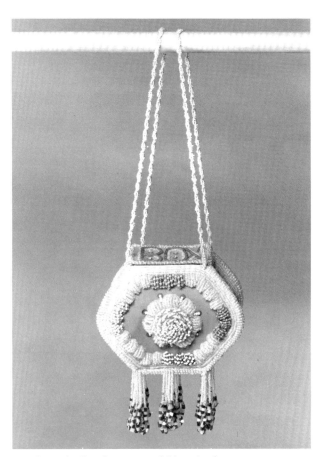

116. Iroquois (Caughnawaga style) hanging box
1911
Embossed and spot-stitch applique beadwork; cardboard, wool, glass beads
Pink wool; clear, white, blue, green, gold, yellow, red and pink beads; metal spangles
8 h.×6.75 w.×4.25 d. in. (20.3×17.2×10.8 cm.)
This type of humorous object truly deserves the name it is generally known by: "whimsey." It represents a kind of baroque expression of the Iroquois beadwork tradition, and was playfully conceived and executed. Few pieces of this type show any indication of use; they were appreciated as decorative *tours de force* and were displayed as ornaments.

Other Sources Consulted

Allen, Elsie. *Pomo Basketmaking: A Supreme Art for the Weaver.* Healdsburg, California: Naturegraph Publishers, 1972.

American Indian Art: Form and Tradition. Minneapolis: Minneapolis Institute of Arts and Walker Art Center, 1976.

Arizona Highways 50, 7 (July 1974).

Arizona Highways 51, 7 (July 1975).

Ashton, Robert Jr. "Nampeyo and Lesou," *American Indian Art* 1, 3 (Summer 1976): 27–33.

Babcock, Barbara. "Clay Changes: Helen Cordero and the Pueblo Storyteller," *American Indian Art* 8, 2 (Spring 1983): 31–39.

Babcock, Barbara A., Guy Monthan, and Doris Monthan. *The Pueblo Storyteller.* Tucson: University of Arizona Press, 1986.

Baird, Genevieve. *Northwest Indian Basketry.* Washington: Washington State American Revolution Bicentennial Commission and Washington State Historical Society, 1976.

Beads: Their Use By Upper Great Lakes Indians. Grand Rapids, Michigan: Grand Rapids Public Museum, 1977.

Bennett, Kathy. "Navajo Chief Blanket: A Trade Item Among Non-Navajo Groups," *American Indian Art* 7, 1 (Winter 1981): 62–69.

Clark, Hattie. "A Storyteller in Clay," *Christian Science Monitor,* November 2, 1987, p. 27.

Coe, Ralph T. *Lost and Found Traditions: Native American Art 1965–1985.* Seattle: University of Washington Press, 1986.

———. *Sacred Circles.* Kansas City, Missouri: Nelson Gallery of Art, Atkins Museum of Fine Arts, 1977.

Cusick, Martha Lanman. *Nampeyo: A Gift Remembered.* Evanston: Mitchell Indian Museum, 1983.

Dittert, Alfred E. Jr. and Fred Plog. *Generations in Clay: Pueblo Pottery of the American Southwest.* Flagstaff: Northland Press, 1980.

Dozier, Edward P. *The Pueblo Indians of North America.* New York: Holt, Rhinehart and Winston, 1970.

Evans, James Leroy. *The Indian Savage, the Mexican Bandit, The Chinese Heathen—Three Popular Stereotypes.* Austin: Ph.D. dissertation, University of Texas, 1967.

Fields, Virginia. *The Hover Collection of Karok Baskets.* Eureka, California: Clarke Memorial Museum, 1985.

Frank, Larry and Francis H. Harlow. *Historic Pottery of the Pueblo Indians, 1600–1880.* Boston: New York Graphic Society, 1974.

Gilham, F.M. *Pomo Indian Baskets* (dealer's catalogue). Highland Springs, California, c. 1916.

Gordon, Beverly. *Domestic American Textiles: A Bibliographic Sourcebook.* Pittsburgh: The Center for the History of American Needlework, 1978.

———. "The Souvenir: Messenger of the Extraordinary," *Journal of Popular Culture* 20, 3 (Winter 1986): 136–146.

Harlow, Francis H. *Modern Pueblo Pottery 1880–1960.* Flagstaff: Northland Press, 1977.

Hollister, U. S. *The Navajo and His Blanket.* Arizona: Rio Grande Press, 1903.

Holm, Bill. *The Box of Daylight.* Seattle: Seattle Art Museum and University of Washington, 1983.

Indian Basketry of Western North America. Santa Ana: The Bowers Museum, 1977.

"Indian Baskets, Rare Works of Art by Aborigines of Washington and Alaska," July 22, 1900, *Seattle Post-Intelligencer,* reprinted in *American Indian Basketry* 2, 3 (August 1982): 8–11.

James, George Wharton. *Indian Basketry and How to Make Indian and Other Baskets.* New York: Henry Malkan, 1903.

———. *Indian Blankets and Their Makers.* Chicago: A.C. McGlurg, 1892.

Kent, Kate Peck. *The Story of Navajo Weaving.* Cambridge: Harvard University Press, 1961.

Lanford, Benson L. "Winnebago Bandolier Bags," *American Indian Art* 9, 3 (Spring 1984): 30–37.

Lobb, Allan. *Indian Baskets of the Northwest Coast.* Portland: Graphic Arts Center, 1978.

Lopez, Raul A. and Christopher L. Moser. *Rods, Bundles and Stitches: A Century of Southern California Basketry.* Riverside, California: Riverside Museum Press, 1981.

Lurie, Nancy Oestreich. "Collecting Contemporary Indian Art," paper presented at the Native American Art Studies Association conference, Denver, Colorado, September 25, 1987.

Lyford, Carrie A. *Quill and Beadwork of the Western Sioux.* Washington: United States Department of the Interior, Indian Handcrafts Series, 1940 (rpt. ed. Stevens Point, Wisconsin: R. Schneider, 1983).

———. *Ojibwa Crafts.* Washington: United States Department of the Interior, Indian Handcrafts Series, 1943 (rpt. ed. Stevens Point, Wisconsin: R. Schneider, 1984).

Maxwell Museum of Anthropology. *Seven Families in Pueblo Pottery.* Albuquerque: University of New Mexico Press, 1974.

McGeevy, Susan. "Navajo Sandpainting Textiles at the Wheelwright Museum," *American Indian Art* 7, 1 (Winter 1981): 54–61.

Mohawk, Micmac, Maliseet and Other Indian Souvenir Art From Victorian Canada. London: Canada House Cultural Centre Gallery, 1985.

Monthan, Guy and Doris. "Dextra Quotskuyva Nampeyo," *American Indian Art* 2, 4 (Autumn 1977): 58–63.

———. "Helen Cordero." *American Indian Art* 2, 4 (Autumn 1977): 72–76.

Navajo Folk Sculpture: Alfred Walleto. Santa Fe. The Wheelwright Museum, n.d. (c. 1979).

Newman, Sandra Corrie. *Indian Basket Weaving: How to Weave Pomo, Yurok, Pima and Navajo Baskets.* Flagstaff: Northland Press, 1974.

Orchard, William C. *Beads and Beadwork of the American Indian: A Study Based on Specimens of the Museum of the American Indian.* New York: Heye Foundation, 1929, 1975.

Ray, Dorothy Jean. *Aleut and Eskimo Art: Tradition and Innovation in South Alaska.* Seattle: University of Washington Press, 1981.

Robinson, Bert. *The Basket Weavers of Arizona.* Albuquerque: University of New Mexico Press, 1954.

Schneider, Richard C. *Crafts of the North American Indians: A Craftsman's Manual.* New York: Van Nostrand Reinhold, 1972.

Silva, Arthur M. and Wiliam C. Cain. *California Indian Basketry: An Artistic Overview.* Cypress, California: Cypress College Fine Arts Gallery, 1976.

Speck, Frank Goldsmith. *The Iroquois.* Bloomfield Hills: Cranbrook Institute of Science, 1945.

Tanner, Clara Lee. *Apache Indian Baskets.* Tucson: University of Arizona Press, 1982.

———. *Indian Baskets of the Southwest.* Tucson: University of Arizona Press, 1983.

Teleki, Gloria Roth. *Collecting Traditional American Basketry.* New York: E.P. Dutton, 1979.

Watkins, Frances E. "Ottawa Indian Quill Decorated Birchbark Boxes," *The Masterkey* 9, 4 (July, 1934): 123–127.

Whiteford, Andrew Hunter "The Origins of Great Lakes Beaded Bandolier Bags," *American Indian Art* 11, 3 (Summer 1986): 32–43.

———. *North American Indian Arts.* New York: Golden Press (Racine: Western Publishing Company), 1970.

Indian Tribes Whose Work
is Represented in the Exhibition*

1. Acoma Pueblo
2. Apache
3. Assiniboin
4. Athapascan
5. Chemehuevi
6. Cherokee
7. Chippewa (Ojibwa)
8. Chitimacha
9. Cochiti Pueblo
10. Eskimo
11. Hopi
12. Iroquois (a tribal federation)
 A. Caughnawaga Reservation
 B. Tuscarora Reservation
 C. Seneca
 D. Mohawk
13. Karok
14. Makah
15. "Mission" Indian
16. Navajo

17. Nez Perce
18. Nootka
19. Ottowa
20. Panamint
21. Papago
22. Pima
23. Pomo
24. Salish
25. Santa Clara Pueblo
26. Santo Domingo Pueblo
27. Sioux
28. Tlingit
29. Ute
30. Washoe
31. Winnebago
32. Yakima
33. Yankton-Sioux
34. Yokuts
35. Zia Pueblo
36. Zuni Pueblo

*Note: Where a tribe has more than one location, the desig-
nated area represents the place the pieces actually came from.*

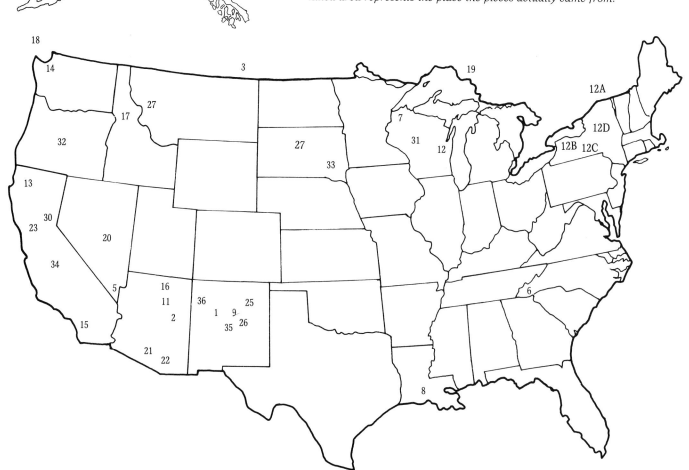

Design: Earl J. Madden
Layout: Barry R. Carlsen
Photography: Liz Loring
Printing: American Printing